AIKEN
THOROUGHBRED
RACING CHAMPIONS

AIKEN
THOROUGHBRED
RACING CHAMPIONS

LISA J. HALL

THE
History
PRESS

Published by The History Press
Charleston, SC
www.historypress.net

Front cover, top: Aiken Thoroughbred Racing Hall of Fame Archives;
bottom: author's collection.
Back cover, top: Aiken Thoroughbred Racing Hall of Fame Archives; *bottom*: courtesy of
Adam Coglianese.

First published 2017

Manufactured in the United States

ISBN 9781625858351

Library of Congress Control Number: 2016961484

For Blue Peter, 1948 Champion Two-Year-Old Colt, who inspired my love of horses and Thoroughbred racing.

CONTENTS

PREFACE

When I was a little girl, I remember going to the Aiken Trials, held every March, to watch the young horses in training race for the first time. I enjoyed the opportunity to experience every aspect of live racing. There was a point in the day when I wandered over to a large live oak tree in the track's infield. There, I discovered a granite marker with the following inscription:

BLUE PETER 1946–1950 WAR ADMIRAL– CARILLON CHAMPION 2 YR. OLD 1948.

I was fascinated by the fact that a champion racehorse was from Aiken and buried here at the training track. That began for me a lifelong love of horses and Thoroughbred racing. Eventually, I would be put in charge of the Aiken Thoroughbred Racing Hall of Fame and Museum.

In order to be inducted into the Aiken Thoroughbred Racing Hall of Fame, a horse must meet two requirements. First, the horse must have spent some part of its racing career training in Aiken. Second, the horse must have been named a champion (prior to 1971, champions were recognized separately by several organizations, including the Thoroughbred Racing Association, the Daily Racing Form and *Turf & Sport Digest*), or it must have won an Eclipse Award (1971–present). There are several categories (over time, category names have sometimes changed). They are as follows:

Overall Horse of the Year
Two-Year-Old Male (colt or gelding)
Two-Year-Old Female (filly)
Three-Year-Old Male (colt or gelding)
Three-Year-Old Female (filly)
Handicap Male (older colt or gelding)
Handicap Female (older filly)
Turf Male (colt or gelding)
Turf Female (filly)
Sprinter (male or female)
Steeplechase (Hurdle Horse)

Induction ceremonies for the Aiken Thoroughbred Racing Hall of Fame are usually held on the Sunday following the Aiken Trials, which is held in March at the Aiken Training Track.

Aiken, rich in equine history, is very fortunate to have had forty national champion Thoroughbreds train at the historic Aiken Training Track. This book concentrates on the years in which they were named a National Champion or won an Eclipse Award. It is my hope that you will enjoy this book and make a pilgrimage to the Aiken Thoroughbred Racing Hall of Fame to learn more about Aiken's racing champions.

ACKNOWLEDGEMENTS

I would like to thank the following individuals and organizations for their contributions to this book: the forty champion racehorses that trained in Aiken; the local trainers, grooms, hot walkers, exercise riders, ground crews and all the other unsung heroes; the stables, past and present, that have and still are training their horses at one of the best training tracks in the world; the Aiken Training Track, particularly Brad Stauffer and Nikki Ridenour, for their support and encouragement; the late Joan Tower, for her dedication to and hard work for the Aiken Thoroughbred Racing Hall of Fame and Museum; the late Whitney Tower, who compiled the background information on the first horses that were inducted; Larry Gleason, for providing the photo of the Aiken Thoroughbred Racing Hall of Fame; Aiken Aerial Photography, for the aerial photo of the Aiken Training Track; the *Aiken Standard*, for providing photos; Adam Coglianese, for providing photos; Keeneland Library in Lexington, Kentucky, for providing photos; the City of Aiken Parks, Recreation & Tourism Department; the Aiken Thoroughbred Racing Hall of Fame Advisory Board, past and present, for its encouragement and support; Aiken, South Carolina, for being a great place to grow up and love horses; all my family and friends, for their encouragement and support; Chad Rhoad and all the staff at The History Press; Clan McShelties (my Shetland Sheepdogs), who reminded me to take time away from writing to go outside and play.

1

A BRIEF HISTORY OF THE AIKEN TRAINING TRACK

Notice was given in the April 30, 1941 edition of the *Aiken Standard and Review* that Devereux Milburn, F.S. von Stade and William B. Wood would file a written declaration with the secretary of state of South Carolina requesting the issue of a charter for the Aiken Training Track. The track officially received its charter on May 6, 1941, and Fred H. Post was named its supervisor. Frank Phelps of Lexington, Kentucky, laid out and supervised the building of the track, and Ira Coward was named the superintendent of labor. The track was modeled after the Keeneland Track in Lexington. The track was one mile in length, the chute was an eighth of a mile, "Horine turns" (flattened curves) were installed and the stretch was seventy feet wide. The track had sixty-foot-wide turns and backside and a steeplechase course in the infield. The track construction costs were $52,000 ($851,997 in today's dollars, according to Consumer Price Index Conversion Factors). The track was completed and opened in November 1941. There were a total of two hundred horses booked to train at the Aiken Training Track in the spring of 1942. Notable owners in November 1941 included John H. Whitney (thirty-five horses in training), George H. "Pete" Bostwick (twenty horses in training), Mrs. Ogden Phipps (ten horses in training), William Post (eighteen horses in training), Brookmeade Stable (forty horses in training) and Lindsay C. Howard/ Bing Crosby Stable (twelve horses in training). During the "Golden Age of Racing"—according to some experts, the 1930s through the 1960s—the

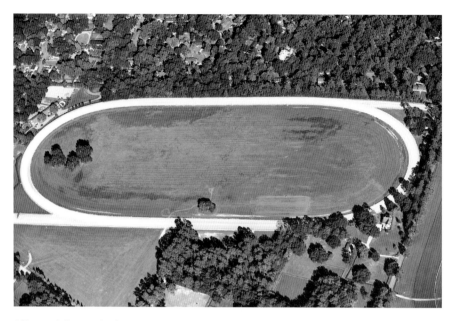

Aiken training track. *Courtesy Larry Gleason, Aiken Aerial Photography.*

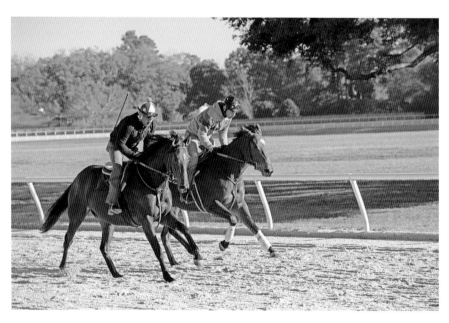

Two-year-olds in training at the Aiken Training Track. *Aiken Racing Hall of Fame Archives.*

Aiken Training Track was the home of flat and steeplechase racehorses that were owned by some of the richest and most famous people in the world, including Elizabeth Arden, Walter P. Chrysler, Isabel Dodge Sloane, John D. Hertz, Louis B. Meyer and Alfred Gwynne Vanderbilt Jr.

2

A BRIEF HISTORY OF THE AIKEN THOROUGHBRED RACING HALL OF FAME AND MUSEUM

The Aiken Thoroughbred Racing Hall of Fame began as an idea of the Aiken Jaycees. The Jaycees wanted to establish a lasting tribute to the famous horses that trained in Aiken and the equine industry that has played an important part in Aiken's history. The first hurdle to be cleared in the completion of this project was finding a location for the Hall of Fame.

The Carriage House, built in 1902, at Hopelands Gardens was chosen for two reasons. One, it was the location of a public garden owned by the City of Aiken. Two, Hopelands was the former estate of Mrs. C. Oliver Iselin, a noted horsewoman who owned stables in America and England. She was a Winter Colony resident, as were many of the owners, breeders and trainers of the horses that were inducted. The Jaycees then went before the Aiken City Council to ask permission to utilize the Carriage House for the Hall of Fame. The mayor and council eagerly supported the project.

The project floundered for about a year until help came from Mr. and Mrs. Whitney Tower. At the time, Mr. Tower was the vice president of the National Racing Museum and chair of the Hall of Fame that is located in Saratoga, New York. He was also the horse-racing editor for *Sports Illustrated* and later the turf writer for *Classic* magazine. Tower helped compile the background information on the first horses that were to be inducted. His wife, Joan, became the chairperson of the fundraising committee. Through her efforts, the Aiken City Council, on May 18, 1976, donated $5,000 toward the renovations of the Carriage House. The remaining funds, $15,000,

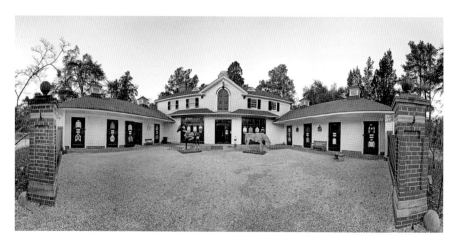

Aiken Thoroughbred Racing Hall of Fame and Museum. *Courtesy Larry Gleason.*

were raised through donations from the Aiken community and the Aiken horse industry. The Aiken Jaycees, at the conclusion of the renovations, had contributed over $10,000 in labor and material costs. The grand opening for the Hall of Fame was held on Sunday, January 23, 1977. Among those in attendance were Mayor H.O. Weeks; John Surles, a former president of the Jaycees and chair of the Hall of Fame Development Committee; Joan Tower, chairperson of the fundraising committee; and James D. McNair, a Hopelands trustee. Monsignor George Lewis Smith, an active rider, gave the dedication prayer. Many of the world's best trainers, including John M. Gaver, MacKenzie T. Miller, James W. Maloney, E. Barry Ryan, Virgil W. Raines, Willard C. Freeman, Mrs. William Post and Mrs. J.D. Byers (the last two representing their husbands), were present to see their charges inducted into the Hall of Fame.

AIKEN'S RACING CHAMPIONS

Assagai

Assagai, a dark-brown horse, was foaled at Clovelly Farms in Lexington, Kentucky, on April 5, 1963. His sire was Warfare, who was descended from Man o' War on his dam's side. A gray stallion that was bred by C.H. Jones & Sons and owned by Bellehurst Stable, Warfare was best known for winning the 1959 Champagne Stakes. Assagai's dam was English-born Primary II, which had only two offspring, Assagai and Boot Camp. Assagai was owned by Charles W. Engelhard Jr., owner of Cragwood Stable. Engelhard (1917–1971), an American businessman, controlled an international mining and metals conglomerate and was a major owner in Thoroughbred racing. Assagai was purchased at the 1964 Saratoga Yearling Sales for $24,000. He was trained by National Racing Hall of Fame trainer MacKenzie Miller (1921–2010).

Assagai's race career began in 1965, when he started in eight races, on the dirt, winning none and only managing one second and one third. The beginning of 1966 saw Miller make a change from the dirt to the turf, with fantastic results. He would win six races in thirteen starts. Assagai won his first graded stakes race on the turf on June 29 at the Long Branch Stakes at Monmouth Park. He would also win the Bernard Baruch Handicap, the Man o' War Stakes, the United Nations Handicap and the Tidal Handicap.

The Bernard Baruch Handicap took place at Saratoga Race Course on August 10. This race was a fairly new one on the stakes schedule, with the

1966 race being the eighth running. His jockey, Larry Adams, kept Assagai in fifth place almost from the start, making a move in the final two furlongs to win by three lengths over Mrs. John Thouron's Ginger Fizz in 1:40, setting a new American record for one mile on the turf.

The Man o' War Stakes was held on October 22 at Aqueduct Racetrack. Assagai and Buckland Farm's Gallup Poll battled back and forth the entire race, with Assagai taking the lead late in the final stretch and winning by three-quarters of a length. The win was the first time a three-year-old won this weight-for-age classic and demonstrated once again his fondness for grass racing. Assagai wrapped up 1996 by winning eight races in thirteen starts with one second, one third and $244,230 in earnings. He was named the 1966 Champion Grass Horse.

He would race one more season, 1967, winning three races (two graded stakes) in ten starts, with four seconds. His three-year career ended with thirty-one starts, including eleven wins (seven graded stakes), seven seconds, two thirds and career earnings of $357,041.

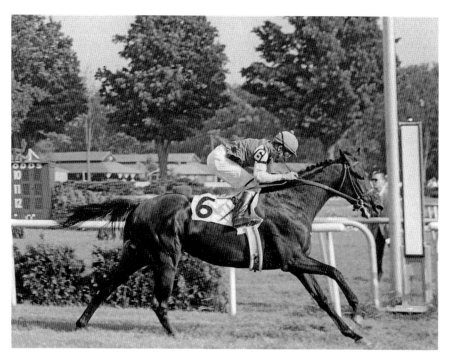

Assagai winning the 1966 Bernard Baruch. *Aiken Thoroughbred Racing Hall of Fame Archives.*

He was retired in 1968 and sent to stud duty, first at Ocala Stud in Florida. He was later sent to Clear Creek Stud in Folsom, Louisiana. Assagai was euthanized due to laminitis in 1986 and buried at Clear Creek Stud. He was elected to the Aiken Thoroughbred Racing Hall of Fame on January 23, 1977.

BARNABY'S BLUFF

Barnaby's Bluff, a bay gelding, was foaled in Kentucky on April 28, 1958. His sire, Cyclotron, bred by Calumet Farm, had a race record of fifteen wins in fifty-seven starts. His dam was Ophelia Rose, who was bred by Ernst Farm and whose great-grandsire was Man o' War through her sire's line. Barnaby's Bluff was owned, bred and trained by George H. "Pete" Bostwick (1909–82), a world-renowned court tennis player, steeplechase rider and trainer and former eight-goal polo player.

Barnaby's Bluff's racing career began in 1960, entering only one race and not placing. The next year was a better one—in ten starts, he won six races and finished second in two races. He won four graded stakes races: the Promise Hurdle Steeplechase, the Annapolis Hurdle Stakes, the Elkridge Hurdle Steeplechase and the L.E. Stoddard Jr. Steeplechase Stakes. His earnings for 1961 were $40,625.

Barnaby's Bluff's 1962 season was an excellent one. The Brook Steeplechase Handicap was run on October 4 at Belmont Park. There were four other horses competing, and Barnaby's Bluff was the longshot for the 2½-mile race. Barnaby's Bluff set a course record in 4:37 1/5, winning by six lengths over Kampina and Blackmail, who finished third.

The Grand National Steeplechase Handicap is the holy grail sought by all owners and trainers. Bostwick was the Sir Galahad of this quest, having already won this race three times: in 1951 with Oedipus and in 1957 and 1958 with Neji. The 1962 Grand National was held on October 16 at Belmont Park. Barnaby's Bluff was the favorite to win. His jockey, Tommy Walsh, guided the gelding from third place at the start of the race to second place after a mile and a half, then to the lead at the two-mile mark. Barnaby's Buff won by just under two lengths over Pocket Rocket and eight lengths over Becky's Ship. Barnaby's Bluff set

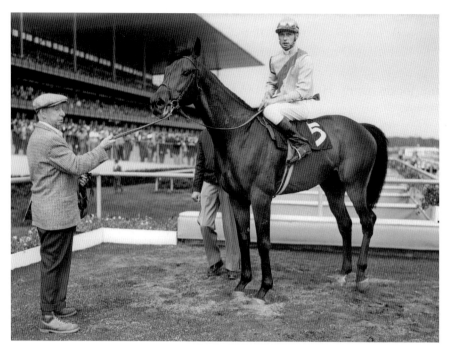

Barnaby's Bluff after winning the 1966 Look Around. *Aiken Thoroughbred Racing Hall of Fame Archives.*

a new course record, 5:52 2/5, for the 2½-mile race. He was named the 1962 Champion Grass Horse.

He would race one more season, 1963, starting in six races and claiming three seconds and one third. His four-year career ended with twenty-eight starts, including eleven wins (seven graded stakes), seven seconds, two thirds and career earnings of $124,346. Tragically, Barnaby's Bluff died after suffering a fatal fall at the fourteenth fence in the 1963 Brook Steeplechase Handicap. He was elected to the Aiken Thoroughbred Racing Hall of Fame on January 23, 1977.

BLUE PETER

This bay horse was foaled at Claiborne Farm in Paris, Kentucky, on March 21, 1946. His sire, War Admiral, and grandsire, Man o' War,

are both members of the National Racing Hall of Fame. His dam was Carillon. Blue Peter was owned and bred by Joseph M. Roebling (1907–80), owner of Harbourton Stud Farm in New Jersey and a member of the Jockey Club. He was related to the Roebling family who built the Brooklyn Bridge. Blue Peter was trained by Andy Schuttinger (1882–1971), a highly successful jockey whose wins included the Travers Stakes, the Jockey Club Gold Cup and the Preakness Stakes. Among the many top horses he rode was Man o' War, guiding him to a win in the 1920 Midsummer Derby at the Saratoga Race Course.

Blue Peter raced for the first time at Garden State Park on April 17, 1948, finishing third in a 4½-furlong race. The next week, on April 24, Schuttinger raced Blue Peter in another 4½-furlong race, winning in a time of 0:52 1/5, a new course record. He was entered in the Youthful Stakes on May 1, 1948, at Jamaica Race Course. There were eight colts in this race. Blue Peter was not the favorite in this 5-furlong race and finished third.

He was entered in a five-furlong allowance race at Garden State Park on May 18 that he led from start to finish. Blue Peter was ridden for the first time by Wayne Wright, who guided him to the win over Noble Impulse by three lengths and set a new track record of 0:59 1/5. He would meet Noble Impulse again at the William Penn Stakes at Garden State Park in a five-furlong race. Wright, up on Blue Peter again, guided him to a three-length lead at the beginning of the race. Noble Impulse started to quickly close on Blue Peter in the stretch and Wright had to encourage his charge to win the race by three-fourths of a length in a time of 0:58 3/5.

The Garden State Stakes was held on May 31 at Garden State Park. Nobel Impulse would have the opportunity to finally be victorious against Blue Peter. This was another five-furlong race, and Wright would be in the saddle again. Irish Sun broke first and led until the quarter pole, when Blue Peter caught him, pulled away and then won by 4½ lengths in a time of 0:58 4/5. Noble Impulse finished second yet again.

After his victory in the Garden State Stakes, Blue Peter was given almost two months to rest before his next race, the Sapling Stakes at Monmouth Park on July 28. He was the heavy favorite going in to this race and would compete against stablemate Harbourton. Eric Guerin would be his new rider. Blue Peter led from start to finish and won easily by six lengths, galloping across the finish line. He won the six-furlong race in a time of 1:12 4/5.

Blue Peter was getting the reputation of being unbeatable. In his next race, the Saratoga Special, known as the "most sporting race in America," only three horses were "sporting" enough to challenge him. This was a winner-take-all, 6½-furlong race. Blue Peter won by four lengths. His next race was the Hopeful Stakes, another 6½-furlong race, at Saratoga, held on August 28. Blue Peter was the favorite again, and Guerin rode him to an easy win in a time of 1:19 1/5.

Blue Peter's last race of the year was the September 25 Futurity Stakes at Belmont Park. There were some who saw this race as the 1948 championships for two-year-olds, pitting Blue Peter against Myrtle Charm, owned by Maine Chance Farm. The Futurity was 6½ furlongs on a straight course. Olympia got out of the gate quickly and took the early lead. Blue Peter, Myrtle Charm and Slam Bang quickly caught him at the end of the first quarter of the race. In the second quarter of the race, Blue Peter took the lead by going on the right of Myrtle Charm and Olympia. Both Ted Atkinson and Olympia's rider, Willie Garner, rode their mounts hard to catch up to Blue Peter. Eric Guerin, Blue Peter's rider, pushed the horse to give more than in any other race he had run. Just fifty yards from the finish line, Myrtle Charm was almost even with Blue Peter's shoulder, but the son of War Admiral would not be denied the victory. Blue Peter won by half a length in a time of 1:14 3/5, just a fifth short of tying the track record. Myrtle Charm finished second, and Sport Page passed Olympia for third. This was the first Futurity win for Blue Peter's owner, Joseph M. Roebling, and his trainer, Andy Schuttinger. He was named the 1948 Champion Two-Year-Old Male Horse.

Blue Peter returned to training in early 1949 and was considered one of the favorites for the 1949 Kentucky Derby. He trained for the first three months of 1949 without issue, but a headline in the April 15, 1949 edition of the *Aiken Standard and Review* shocked the racing world: "Blue Peter Is Out of Derby Race This Year." The given cause was an attack of appendicitis along with a fever of 103.5 degrees that left him weak and unable to train. Schuttinger said that it was in the horse's best interest to be given time to heal. Unfortunately, Blue Peter did not recover well enough to compete for the rest of 1949.

He began to train again at the Aiken Training Track in December 1949 and appeared to have recovered from his illness. However, in early January, he developed pneumonia and had to cease training. Blue Peter passed away in his stall at the Aiken Training Track on January 12, 1950. It was thought

that he had another attack of appendicitis; that, coupled with pneumonia, was too much for him to recover. His death was reported in newspapers all over the country. Blue Peter was laid to rest on January 13, 1950, underneath a large live oak in the infield of the Aiken Training Track. The *Aiken Standard and Review* reported on the funeral in its January 18, 1950 edition.

SPORTS SCOPE In "The Sports Center of the South"
By Harvey McConnell

A race horse who might have been one of the greatest yet was buried here last Friday. Blue Peter owned by Mr. Joseph M. Roebling died Thursday of an intestinal disorder. In the first ceremony of its kind to be held here Blue Peter, was laid to rest in the infield of the Training Track. His six-foot grave is under a large oak tree. Blue Peter was placed in a large pine coffin and his body was covered with a yellow and red blanket which was monogramed with the owner' initials J.M.R. The coffin was lowered into the grave by the means of ropes. Some 25 or 30 horse fanciers attended the funeral. As the horse was lowered into his grave many of the spectators wept. The grief was seen most in trainer Andy Schuttinger who considered Blue Peter the best horse that he had ever trained. It was Schuttinger who trained this horse who was almost unanimously declared the best two-year-old in 1948. Last winter he was the winter book favorite in the Kentucky Derby, but he became sick in April and did not run. He was rested from then until he started winter training and was doing pretty well until he took sick recently. His winnings as a two year old totaled $189,185. Blue Peter was bred in the blue grass country of Kentucky. He was out of Carillion, a mare by Case and Man of War's son, War Admiral. He started his racing career slowly. At Garden City in his first start he finished third in a mediocre field. However soon after that he set a record for four and a half furlongs at the same park. Sending Blue Peter to Jamaica he finished third in the Youthful Stakes.

This was the last race that he ever lost. He never in his life finished out of the money. He won the William Penn and Garden stakes at the Garden City, N.J. track. He was then layed [sic] off for two and half months. He came back to win the Monmouth Park Sapling Stages. He won the Special and Hopeful stakes when the Saratoga track opened. The climax to his career came when he ran in the Belmont Futurity. He beat Olympia by half

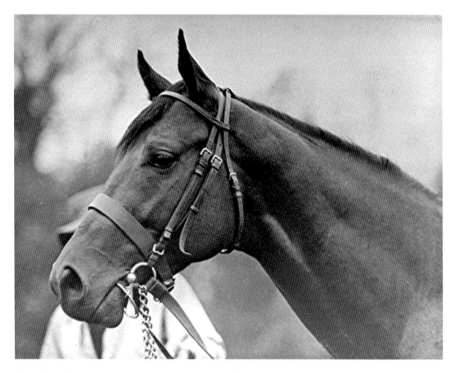

Blue Peter, date and location unknown. *Aiken Thoroughbred Racing Hall of Fame Archives.*

a length to set a new world record for event. This clinched his recognition as the nation's top two year old. Thus ended the career of a racing horse that seemed destined to be one of the best horses of all times, but death cut short his career.

His one-year career ended with ten starts, including eight wins (six graded stakes), two thirds and career earnings of $189,185. Blue Peter was elected to the Aiken Thoroughbred Racing Hall of Fame on January 23, 1977.

BOWL GAME

Bowl Game, a bay gelding, was foaled in Kentucky on April 20, 1974. His sire was Tom Rolfe, winner of the 1965 Preakness Stakes and the 1965 American Champion Three-Year-Old Male Horse. His dam was Around

the Roses, whose sire was Round Table. Round Table is still considered the greatest turf horse in American racing history. Bowl Game was bred by Greentree Stud and owned by Greentree Stable. Greentree was established in 1914 by Payne Whitney of the Whitney family of New York City. Greentree Stable had a training base at the Aiken Training Track; Greentree Farm in Lexington, Kentucky, was established in 1925 as its breeding arm. He was trained by John Gaver Jr.

Bowl Game's racing career began in 1977 with only two starts; he placed third in both races. His stats in 1978 were much better: six wins (three graded stakes) in ten starts, with three seconds, one third and $311,245 in earnings. He won his first race on February 15 in a Maiden Special Weight race and then won two allowance races, on February 24 and March 4, all at Hialeah Park. Bowl Game would then win his next three starts, all graded stakes contests. He won the Gulfstream Park Handicap, the Pan American Handicap (turf) at Gulfstream Park and the Dixie Handicap (turf) Pimlico Race Course. Jorge Velasquez was Bowl Game's jockey for all of his 1978 races.

The year 1979 would be a stellar one for Bowl Game. He was entered in ten races, winning five: the Turf Classic (Grade 1), the Washington, D.C. International (G1), the Man o' War Stakes (G1), the Hialeah Turf Cup Handicap (G2) and the Arlington Handicap (G2). The Arlington Handicap, held on September 1, was a 1½-mile turf race that hosted a large field of fourteen horses. Bowl Game was not the favorite in this race, but he would prove the odds makers wrong. He was content to hang in the back of the field at the beginning of the race. Bowl Game's regular jockey, Jorge Velasquez, guided his charge to pass his competitors after the third turn. In the stretch, Bowl Game passed leader Young Bob and won comfortably by 4½ lengths in a time of 2:32.20.

Bowl Game's last race of 1979 was the Washington, D.C. International on November 10 at Laurel Park. Bowl Game was racing against Trillion, Native Courier and Waya and four other horses for 1½ miles on the turf. He would set the pace on the outside under the reins of Velasquez. Bowl Game fell back a bit after the second turn, but Velasquez patiently waited and, when the pace quickened at the mile mark, he drew his charge to the outside and gradually drew clear of the other horses. He won by three-quarters of a length over Trillion in a time of 2:51 on a soft course.

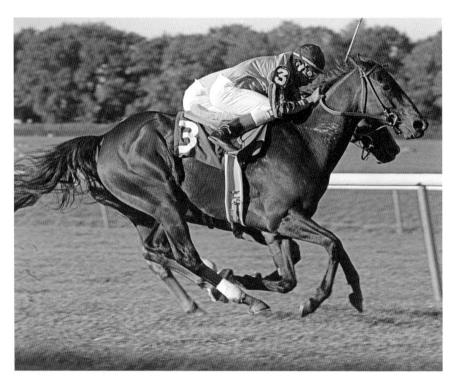

Bowl Game winning the 1979 Turf Classic. *Courtesy of Adam Coglianese.*

Bowl Game won an Eclipse Award as the 1979 Champion Male Turf Horse and was the only horse to have ever won all four prestigious turf races in the United States. He ran once in 1980 in an allowance race at Belmont Park on June 15, finishing second, and he was then retired. His four-year career ended with twenty-three starts, including eleven wins (eight graded stakes), six seconds, five thirds and career earnings of $907,083.

Bowl Game was euthanized on November 11, 2006, at age thirty-two because of the infirmities of old age. He had been under the care of the Thoroughbred Retirement Foundation since 1998 and had been living at the farm of the foundation's president, Johnathan Miller, in Paeonian Springs, Virginia. The gelding was believed to be the oldest living North American champion at that time. He was buried at Miller's Virginia farm. Bowl Game was elected to the Aiken Thoroughbred Racing Hall of Fame on March 16, 1980.

Candy Éclair

Candy Éclair, a gray mare, was foaled in Kentucky on April 14, 1976. Her sire was Northern Jove and grandsire was Northern Dancer, winner of the 1964 Kentucky Derby and Preakness Stakes, the 1964 American Champion Three-Year-Old Male Horse and one of the most successful sires of the twentieth century. Her dam was Candy's Best, whose sire was Candy Spots, winner of the 1963 Preakness Stakes. Candy Éclair was bred and owned by Adele W. Paxson (1913–2000). Paxson's husband, Henry, owned Elm Grove Farm in Bucks County, Pennsylvania, which was used as a breeding facility. Adele Paxson maintained a racing stable in Florida and a barn at the Aiken Training Track. She was the breeder of Heavenly Cause, voted the 1980 American Champion Two-Year-Old Filly. Paxson was given the 1980 Eclipse Award for Outstanding Breeder. Candy Éclair's trainer was S. Allen King.

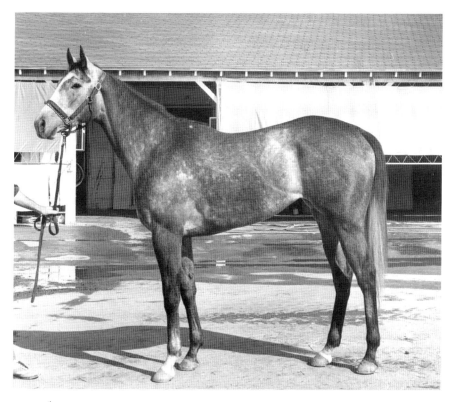

Candy Éclair, date and location unknown. *Aiken Thoroughbred Racing Hall of Fame Archives.*

Candy Éclair's freshman year on the track started with a win in the very first race in which she was entered. It was a five-furlong Maiden Special Weight held on July 5, 1978, at Monmouth Park, and won in a time of 0:59.40. Tony Black, her jockey for 1978, guided Candy Éclair to a win by a neck over Drop Me a Note. Her first stakes race was on September 2 at Atlantic City Racetrack. At the six-furlong Brigantine Stakes, she beat second-place finisher Maybe the Best by six lengths and won in a time of 1:10.

The Mermaid Stakes, a seven-furlong race at Atlantic City, was held on September 30. Candy Éclair won in a time of 1:22.20, beating Salem Ho by two lengths. Candy Éclair's last race of the season would come in the Selima Stakes, held on October 21 at Laurel Park. This was a $1^1/16$-mile race that she won by a length and a half over Whisper Fleet in a time of 1:45.60. Many sports journalists were ready to call Candy Éclair the best two-year-old filly after this race, but she would have to wait until December to find out if she would win that honor.

Candy Éclair won an Eclipse Award as the 1978 Champion Two-Year-Old Filly. She shared the award with It's in the Air, owned by Louis Wolfson's Harbor View Farm. This would be the first time in the eight-year history of the Eclipse Awards that horses would share the award. Candy Éclair won all five of her starts, while It's in the Air posted five wins and three seconds in eight starts. Like Candy Éclair, she won three stakes races. Candy Éclair's record for 1978 was five starts with five wins (three graded stakes) and earnings of $155,896.

She would win two graded stakes in 1979 (the Shirley Jones and the Ashland) and three graded stakes in 1980 (the Grey Flight Handicap, the Endine Handicap and the Regret). Her three-year career ended with twenty-three starts, including fifteen wins (eight graded stakes), four seconds, one third and career earnings of $403,845. She did not have success as a broodmare, producing five foals that didn't succeed on the track. She was elected to the Aiken Thoroughbred Racing Hall of Fame on March 17, 1979.

CAPOT

Capot, a brown horse, was foaled in Kentucky in 1946. His sire was Menow, winner of the 1937 Champagne Stakes and the 1937 Belmont Futurity Stakes and voted the 1937 American Champion Two-Year-Old Male

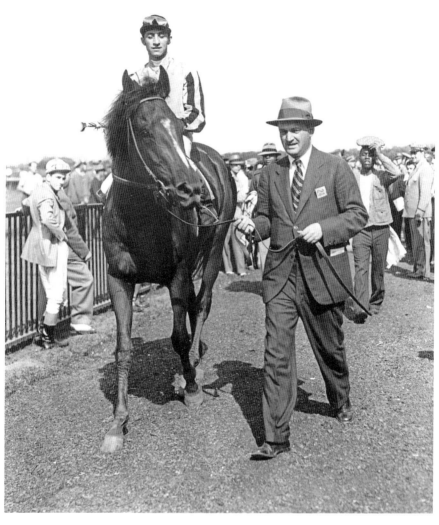

Capot with Eddie Arcaro up, being led by trainer John M. Gaver Sr. after winning the 1949 Preakness Stakes. *Aiken Thoroughbred Racing Hall of Fame Archives.*

Horse. His dam was Piquet. Capot was bred by Greentree Stud and owned by Greentree Stable. Greentree Stable had a training base at the Aiken Training Track, and Greentree Stud, in Lexington, was established in 1925 as its breeding arm. He was trained by John Gaver Sr.

Capot's three-year career began in 1948 with a second-place finish in a Maiden Colts and Geldings race at Belmont Park. His first win came at Belmont Park on May 23 in a five-furlong allowance race. He had a time of 0:59 1/3 with his regular rider, Ted Atkinson, in the irons. He won all the stakes races he entered, with wins in the Pimlico Futurity, Champagne Stakes and Wakefield Stakes. He finished his freshman year with five wins (three stakes wins), two seconds and winnings of $92,150.

Capot was training at the Aiken Training Track and preparing to compete in his sophomore year. Blue Peter, the Champion Two-Year-Old Colt in 1948, was also training at Aiken and was the favorite for the 1949 Kentucky Derby. When Blue Peter became sick in April 1949 and had to be withdrawn from racing the rest of the year, Capot found himself one of the favorites for the Derby.

The 1949 Kentucky Derby was held on May 7 at Churchill Downs, and Olympia was the favorite to win. Palestinian, Old Rockport, Johns Joy, Halt and Capot were considered main contenders. Capot began the race in fifth place, but by the half-mile pole he was in second place. He maintained that position until the top of the stretch, when he moved into the lead. Not much consideration was given to Ponder, owned by Calumet Farm, who started the race slowly and worked his way forward while racing on the extreme outside. He was in third place and was three lengths behind Capot at the top of the stretch. Capot was not able to hold on to the lead, and Ponder won by three lengths. Palestinian finished a strong third.

The 1949 Preakness Stakes was held on May 14 at Pimlico Race Course. Capot and Ponder were the favorites. Crispin Oglebay's Noble Impulse led the race from the start, while Capot stayed in second, close to Noble Impulse, almost the entire race. In the last furlong, Capot drew away on the inside and was able to win by a head over Palestinian, who came up late to pass Noble Impulse for second place. Ponder hovered between ninth and seventh place most of the race, but he was able to make up ground in the stretch and finish in fifth place.

The Belmont Stakes was held on June 11 at Belmont Park. Capot and Ponder each had a Triple Crown victory that year, and many wondered if Palestinian would capture the last jewel. Palestinian broke well from the gate and led the race at the very start, but by the half-mile pole, Capot had taken the lead and would not relinquish it. Palestinian stayed in second place, but Ponder was quickly closing on him. Ponder, in eighth place most of the race, started making up ground and was in fifth at the $1\frac{1}{4}$-mile mark. He had moved up to third at the top of the stretch and beat Palestinian at the finish by a half length and losing to Capot by half a length. Capot was named the 1949 Champion Three-Year-Old Male Horse and the 1949 Horse of the Year.

Capot raced three times in 1950, winning the Wilson Stakes. He had been injured as a foal when he was kicked in the knee. The injury, which required treatment throughout his career, caught up with him and prevented him from performing at his best. Greentree decided to retire him on August 29, 1950, and send him to stud duty at Green Tree Farm. His three-year career ended with twenty-eight starts, twelve wins (ten graded stakes), four seconds, seven thirds and career earnings of $347,260. He sired fifteen foals before he was gelded in 1958. Capot died in 1974 and was buried at Greentree Stud (now Gainesway Farm) in Lexington. He was elected to the Aiken Thoroughbred Racing Hall of Fame on January 23, 1977.

CHRISTMAS PAST

This gray mare was foaled in Kentucky on April 15, 1979. Her sire was the 1964 French Champion Two-Year-Old Colt, Grey Dawn. Her dam was Yule Log, whose sire was Bold Ruler, an eight-time leading sire in North America and a member of the National Racing Hall of Fame. Christmas Past was bred and owned by Cynthia Phipps (1945–2007), a member of one of racing's foremost families. Her father was Ogden Phipps, who raced hall-of-fame member Buckpasser, and her mother was Lillian, a leading member of the steeplechase community. Cynthia's brother Dinny was a prominent breeder/owner and past chairman of the Jockey Club. Cynthia Phipps had a training base at the Aiken Training Track, and Angel Penna Jr. trained her horses.

Christmas Past's three-year career began in in 1981, when she was entered in a Maiden Special Weight race at Belmont Park on September 23. She finished in third place. She would race one more time in 1981, in another Maiden Special Weight race at Belmont Park, finishing in third again. Christmas Past earned only $4,080 in 1981.

She wouldn't break her Maiden until February 1, 1982, at Hialeah Park, winning the 1$\frac{1}{16}$-mile race in a time of 1:45.20. Christmas Past won her first stakes race on March 4, 1982, in the Poinsettia Stakes at Hialeah Park. Jacinto Vasquez, who rode Christmas Past her entire career, guided her win on the 1$\frac{1}{8}$-mile race in a time of 1:49.40. She defeated Newstead Farm's Larida by six lengths and Ryehill Farm's Smart Heiress by thirteen lengths.

Christmas Past and Cupecoys Joy would meet at the Coaching Club American Oaks. The favored Cupecoys Joy was trying to win the last leg of the Filly Triple Crown. Christmas Past ran conservatively, content to stay in fourth for most of the race. She made her charge at the 1$\frac{1}{4}$ pole, taking over first and winning by six lengths over Cupecoys Joy, spoiling her chance at the Filly Triple Crown. Aiken-trained Flying Partner

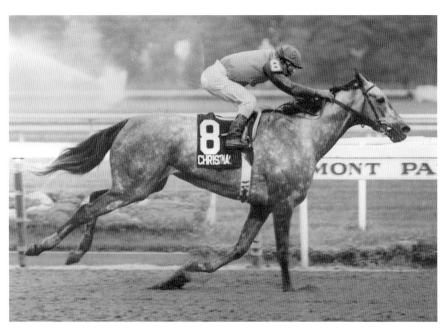

Christmas Past winning the Ruffian Handicap on September 26, 1982. *Aiken Thoroughbred Racing Hall of Fame Archives.*

finished third. Vasquez masterfully guided Christmas Past the distance in 2:28 3/5.

Christmas Past would race next in the Monmouth Oaks at Monmouth Park on July 24. There would be nine horses in the field, competing in the 1⅛-mile contest. She was the favorite, racing out of the ninth-post position. She started the race in sixth and stayed there at the quarter pole and at the half pole, biding her time. Vasquez moved her to third at the three-quarters pole and into the lead at the top of the stretch, a half-length ahead of Milingo, which was owned by Nickels and Dimes Stable. She would win by 1¼ lengths over Milingo in a time of 1:49.40.

At the Ruffian Handicap, run on September 26 at Belmont Park, Christmas Past was the second choice in a field of eight. Broom Dance, scheduled to run as well, was scratched before the race. Christmas Past broke well out of the gate but didn't seem to be worried about running with the leaders, staying in seventh until the three-quarters pole, where she moved into first. She was leading by a length and a half at the top of the stretch and was never in any danger of losing the lead. She won by five lengths over Mademoiselle Forli in a time of 1:48.60.

Her final race of the season was the Jockey Gold Cup at Belmont Park on October 9. This 1½-mile race began as the Jockey Club Stakes and became the Jockey Gold Cup in 1921. There were ten horses in the race, and Timely Writer, owned by Peter and Francis Martin, was the favorite. Timely Writer was in second place early on but dropped down to third at the one-mile mark. Then, with less than a half-mile to go in the race, Timely Writer suddenly fell and sent his jockey over his head. Johnny Dance, owned by Buckland Farm and trained in Aiken, collided with Timely Writer and hit the fence, fracturing his left foreleg. Their riders were not seriously hurt, but both horses had to be humanely euthanized. Christmas Past was able to avoid the collision and finished third in the race in a time of 2:31.20.

Christmas Past finished the year with eleven starts, six wins (five stakes wins), two seconds, one third and $432,960 in earnings. She won the 1982 Eclipse as the Champion Three-Year-Old Filly. She would race one more year, competing only twice and winning the Gulfstream Park Handicap. Her career record was fifteen starts, eight wins (six graded stakes), two seconds, three thirds and career earnings of $563,670.

She was retired in 1983 to broodmare duty at Claiborne Farm in Paris, Kentucky, producing ten foals between 1985 and 2002, none of which won or placed in a stakes race. Christmas Past was euthanized on December 13, 2008, at twenty-nine years of age, due to the infirmities of old age, at Claiborne Farm. She was elected to the Aiken Thoroughbred Racing Hall of Fame on March 3, 1983.

CONNIVER

Conniver, a brown mare, was foaled in Kentucky in 1944. Her sire was Discovery, winner of the 1937 Champagne Stakes and 1937 Belmont Futurity Stakes and voted the 1937 American Champion Two-Year-Old Male Horse. Her dam was The Schemer. Conniver was bred by Alfred G. Vanderbilt II, a member of the prominent Vanderbilt family and a son of Alfred Gwynne Vanderbilt, who died a hero in the sinking of the RMS *Lusitania*. She was purchased as a yearling for $2,500 in 1945 at the Meadow Brook Sale by Harry La Montagne, a sculptor as well as a racehorse owner. He also served in the U.S. Cavalry during World War I and won the French Legion of Honor. Conniver was trained by William Post, who, along with his son Fred, developed their property in Aiken into the Aiken Training Track. Conniver was a big filly, standing at seventeen hands.

Conniver's four-year career began in 1946, when she posted six starts, one third and $400 in earnings. Her sophomore year showed improvement: nineteen starts, three wins, two thirds and $8,800 in earnings. She won her first race on April 24 at Jamaica Race Course in an allowance race for three-year-olds. Her other two wins in 1947 were in allowance races. La Montagne was so disappointed in her performances that he offered to sell her to George H. Bostwick as a polo pony. Bostwick declined, stating that the mare was too big. La Montagne would later be grateful that Bostwick didn't take him up on his offer.

Her junior campaign was her finest, with eighteen starts, nine wins (four stakes races), two seconds, two thirds and $162,190 in earnings. Conniver won the South Shore, Atlantic Beach Graded, Pandora, Nimba and Water Blossom Handicaps. The inaugural running of the Vagrancy Handicap was held on July 10 at Aqueduct, and Conniver was the favorite in a field

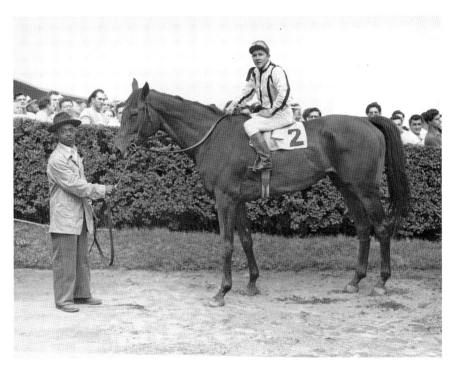

Conniver after winning the Butler Handicap on July 16, 1949. *Aiken Thoroughbred Racing Hall of Fame Archives.*

of eight horses. Rider Ted Atkinson kept Conniver fifth through the half-mile post. He then moved her to the outside coming down the stretch, where she caught up with Arnold Hanger's Harmonica. Conniver won the race by five lengths in a time of 1:43 3/5, four-fifths of a second off the track record.

The Brooklyn Handicap came a week later, on July 17 at Aqueduct. Conniver would face Gallorette, another Aiken-trained horse owned by William L. Brann, and Ethel D. Jacobs's Stymie. Stymie was the favorite, with Conniver the second choice in this 1¼-mile contest. Knockdown, owned by Maine Chance Farm, broke first from the gate and stayed in first place until the top of the stretch, when Conniver and Stymie passed him. The two horses began a battle down the stretch. When they reached the inside of the sixteenth pole, Gallorette had a slight lead. Ted Atkinson urged Conniver for more, and she responded, catching Gallorette, then passing her and winning by a head in a time of 2:05 4/5. Stymie finished third. Some would say that this race was the best of Conniver's season and career.

She raced again in the Beldame Handicap at Aqueduct on September 11. Harmonica and Gallorette, now racing under the colors of Marie A. Moore, were entered to challenge Conniver, which would be ridden by Doug Dodson and was last in the field when the race started. She worked her way through the fourteen-horse field and entered into contention at the last turn. She caught Harmonica in the stretch and won in three lengths in a time of 1:52 2/5. Gallorette finished third.

Conniver would race three more times before the Comely Handicap: the Ladies Handicap, the Jockey Club Gold Cup and the Questionnaire Handicap, finishing fifth in all three races. The Comely Handicap would be run at Jamaica Race Course on October 27. There were ten entries in the $1^1/_{16}$-mile race, with Miss Request and Carolyn A., both owned by Ben Whitaker Stables, favorites to win. Conniver was the third favorite in the field and would be ridden by Eric Guerin. She was in eighth place with a half-mile to go; Miss Request had the lead at the top of the stretch. Conniver made her charge in the stretch and beat Miss Request by a length and a half in a time of 1:45. Carolyn A. finished third.

Conniver ended her year with eighteen starts, nine wins (four graded stakes), two seconds, two thirds and $162,190 in earnings. She was named the 1948 Champion Handicap Female. She would race one more year but failed to match the success of her 1948 season. Her career record was fifty-six starts, with fifteen wins (five graded stakes), three seconds, six thirds and career earnings of $227,825.

She was retired on October 21, 1949, and sent to Claiborne Farm in Paris, Kentucky. She was bred to Double Jay and produced three foals; the most successful was Plotter, which won the Top Flight and Vagrancy Handicaps. She was bred once to Swaps and produced one foal. Conniver died in 1970. She was elected to the Aiken Thoroughbred Racing Hall of Fame on January 23, 1977.

CONQUISTADOR CIELO

Conquistador Cielo, a bay horse, was foaled in Florida on March 20, 1979. His sire was the 1974 Whirlaway Handicap winner Mr. Prospector, who has the distinction of siring one winner of each of the Triple Crown

races: 2000 Kentucky Derby winner, Fusaichi Pegasus; 1985 Preakness Stakes winner, Tank's Prospect; and 1982 Belmont Stakes winner, Conquistador Cielo. Conquistador Cielo's dam was KD Princess, who had a very nondescript racing career. Conquistador Cielo was bred by Lewis E. Iandoli. He was owned by Henryk de Kwiatkowski (1924–2003), an aeronautical engineer originally from Poland who made his fortune through leasing and brokering the sale of used commercial airplanes. He owned Calumet Farm, one of the most historic and prestigious Thoroughbred horse-breeding and racing farms in the United States. Conquistador Cielo was trained by National Racing Hall of Fame member Woody Stephens (1913–1998), who had a training base at the Aiken Training Track.

Conquistador Cielo's two-year career began in 1981 with four starts, two wins (one graded stakes), one third and $49,668 in earnings. He would win his first race on his second try in a Maiden Special Weight race at Belmont

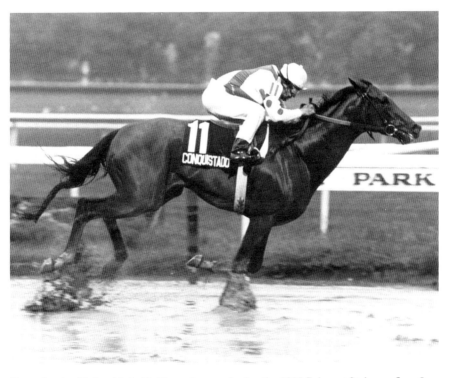

Conquistador Cielo with Laffit Pincay Jr. up, winning the 1982 Belmont Stakes on June 5, 1982. *Aiken Thoroughbred Racing Hall of Fame Archives.*

Park on July 1. He also won the Saratoga Special Stakes on August 3, a six-furlong race held at Saratoga Race Course.

Conquistador Cielo ran in nine races in 1982, conquering many of his competitors. He ran in four allowance races in a row, beginning at Hialeah Park on February 16. Pleasant Colony finished fourth in that race, which was won by Star Gallant, winner of the 1982 Fountain of Youth Stakes. He would then reel off three allowance race victories in a row. His first stakes race of the year came at the one-mile Metropolitan Handicap on May 31 at Belmont Park, with Eddie Maple in the saddle.

Conquistador Cielo broke well from the gate and was in the lead at the quarter pole. He had slipped back to third at the half-mile pole, but by three-fourths of a mile he was back in the lead by two lengths. Headed into the stretch, he was ahead by 5 lengths, and at the finish he won by 7¼ lengths in a time of 1:33, setting a new track record. Silver Buck, who would later sire Silver Charm, the winner of the 1997 Kentucky Derby and Preakness Stakes, finished second.

Five days later, Conquistador Cielo ran in the 114th Belmont Stakes. Eleven horses were entered in the mile-and-a-half race, including Gato Del Sol, winner of the 1982 Kentucky Derby. Conquistador Cielo was in second place at the one-quarter pole and half a length behind the leader, Anemal. When Conquistador Cielo reached the half mile pole, he was in the lead by a length and a half. When he reached the stretch, his lead had increased to ten lengths. When Laffit Pincay Jr. rode him across the finish line, he was fourteen lengths ahead of second-place finisher Gato Del Sol. Prior to Conquistador Cielo winning the Belmont by fourteen lengths, only three horses in the twentieth century had won the Belmont Stakes by more than ten lengths: Secretariat, Count Fleet and Man o' War.

A month later, Conquistador Cielo ran in the Dwyer Stakes and at Belmont Park. Six horses competed in the 1⅛-mile race. Eddie Maple was back up in the stirrups, and he would guide Conquistador Cielo to a win from start to finish. John's Gold, owned by Hobeau Farm, won second, four lengths behind Conquistador Cielo. The winning time of 1:46 4/5 set a new stakes record, breaking the old one of 1:47 set by Coastal in 1979.

The Jim Dandy Stakes, run at a distance of a mile and a furlong, was held on August 8 at Saratoga Race Course. Conquistador Cielo was the overwhelming favorite in a field of four horses. Maple kept him at a

leisurely pace throughout the race, which he won by a length over Lejoli, who was never any threat to his lead. The third-place finisher, No Home Run, finished fifteen lengths behind Conquistador Cielo.

Henryk de Kwiatkowski announced on August 12 that he had syndicated Conquistador Cielo at a record value of $36.4 million. Three-quarters of the rights to Conquistador Cielo ($27.3 million) was sold to a syndicate of breeders organized by Claiborne Farm in Lexington, Kentucky. De Kwiatkowski retained full ownership of the colt until his retirement at the end of the 1982 racing season. Conquistador Cielo was then moved to Claiborne to stand as a stallion.

Conquistador Cielo would race one more time, in the Travers Stakes at Saratoga, finishing third in the August 21 race despite straining a ligament in his left front ankle. De Kwiatkowski and Seth Hancock of Claiborne consulted with Woody Stephens about whether to retire the horse. Stephens felt it would be in the best interest of the horse, for his health and his future as a stallion, to be retired.

Conquistador Cielo finished the year with nine starts, seven wins (four stakes wins), one third and $424,660 in earnings. His career record was thirteen starts with nine wins (five graded stakes), two thirds and career earnings of $474,328. He won an Eclipse Award as the 1982 Champion Three-Year-Old Colt and the 1982 Champion Horse of the Year. He was elected to the Aiken Thoroughbred Racing Hall of Fame on March 3, 1983. Conquistador Cielo died in 2002 and was buried at Claiborne Farm–Marchmont Division in Paris, Kentucky.

DE LA ROSE

De La Rose, a bay mare, was foaled in Kentucky in March 23, 1978. Her sire was Nijinsky, also called "Nijinsky II" in the United States, who won the 1970 English Triple Crown, comprising the 2000 Guineas Stakes, the Epsom Derby and the St. Leger Stakes. Her dam was Rosetta Stone, whose sire was Round Table. Round Table was the 1957–59 Champion Turf Horse, the 1958 and 1959 Champion Male Handicap Horse, 1958 and 1959 Horse of the Year and the 1958 leading sire in North America. De La Rose was bred by Dr. and Mrs. R. Smiser West and MacKenzie

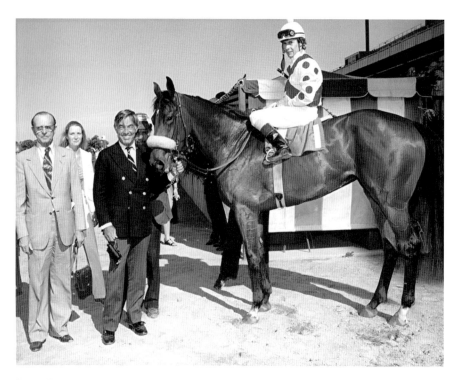

De La Rose with trainer Woody Stephens, owner Henryk de Kwiatkowski and jockey Eddie Maple. *Aiken Thoroughbred Racing Hall of Fame Archives.*

T. Miller. She was owned by Henryk de Kwiatkowski, who also owned Conquistador Cielo. She was trained by National Racing Hall of Fame member Woody Stephens. Stephens had a training base at the Aiken Training Track.

De La Rose's three-year career began in 1980 with eight starts, three wins (one graded stakes), two seconds and $93,431 in earnings. She would win her first race in a Maiden Special Weight race at Belmont Park on July 11. She won her first stakes in the Evening Out Stakes on August 9, a seven-furlong turf race held at Belmont Park.

De La Rose would race on the dirt and the turf in 1981, but it was clear that she favored the grass. She lost her first four races, three of them stakes races, all on the dirt, and she did not place in any of the races. Of her few performances on the dirt, one of her best came in the Kentucky Oaks on May 1 at Churchill Downs, where she finished second to Aiken-trained Heavenly Cause.

She was entered in her first turf race of 1981 on May 23 in a one-mile allowance race at Belmont Park, which she won in a time of 1:33.20. De La Rose would compete in ten more races after this allowance race, winning seven of them. All of her wins came on the turf. She won the 1-mile Grade 2 Saranac Stakes on May 31, beating Stage Door Key, a son of Stage Door Johnny, by 6½ lengths in a time of 1:34.40. Running in the Grade 3 Long Branch Stakes on June 13 at Monmouth, De La Rose won the 1-mile contest in 1:35.60 and finished 8½ lengths in front of Century Banker. De La Rose was then entered in the Grade 1 Coaching Club American Oaks, a 1½-mile race on the dirt at Belmont Park, on June 27, where she would finish last out of six horses. She was back on the turf for the Grade 2 Lexington Handicap on July 26 at Belmont Park. She finished second to Acaroid by 1¼ lengths.

The Grade 2 Diana Handicap at Saratoga would see two Aiken-trained fillies battle for the win in the 1⅛-mile race on August 16. De La Rose won by 1¾ lengths over Rokeby Stable's Rokeby Rose in a time of 1:50.60. Rokeby Rose turned the tables on De La Rose, beating her in the Grade 2 Flower Bowl Handicap on September 7 at Belmont Park in a time of 2:01.60. The Lamb Chop Handicap, named for another Aiken-trained horse, was run on September 30 at Belmont Park. De La Rose won the 1 1/16 mile race in a record time of 1:42 She beat second-place finisher Andover Way, who would become the dam of Dynaformer, by 1¾ lengths.

The Grade 3 Athenia Handicap was run on October 12 at Belmont Park. The 1¼-mile race closed out the fall race season at Belmont Park. De La Rose won this race by 4½ lengths in a time of 2:00.40, equaling the track record. Next on her schedule was the Grade 3 E.P. Taylor Stakes, held on October 17 at Woodbine Racetrack. She was the youngest (three years old) in a field of eight fillies and mares. De La Rose came from behind to win by 2½ lengths in a time of 2:05.40.

De La Rose closed out her 1981 season at the Grade 1 Hollywood Derby on November 15 at Hollywood Park. There were sixteen entries in the 1⅛-mile race, so it was evenly split into two divisions, with De La Rose competing in the first division. She started the race slowly, staying in seventh for the first half of the race, but after the half-mile pole, she began moving up the field. She was in fifth place by the three-quarters pole. At the top of the stretch, she had moved up to take the lead from High Counsel. De La Rose crossed the finish line, winning by a neck over

High Counsel in a time of 1:47.60. De La Rose finished the 1981 season with fifteen starts, eight wins (seven graded stakes), three seconds and $431,090 in earnings. She won an Eclipse Award as the 1981 Champion Female Grass Horse. She raced three times in 1982 and was then retired in April. Her career record was twenty-six starts with eleven wins (eight graded stakes), six seconds and career earnings of $544,647.

She was bred in 1984 to Conquistador Cielo and produced Conquistarose, which won the 1986 Grade 1 Young America Stakes and earned a career total of $487,055. De La Rose was humanely euthanized on March 6, 2001, at twenty-three due to the infirmities of old age. She is buried at Calumet in Lexington, Kentucky. She was elected to the Aiken Thoroughbred Racing Hall of Fame on March 14, 1982.

DEMONSTRATIVE

Demonstrative, a bay gelding, was foaled at Gainsborough Farm, LLC, in Versailles, Kentucky, on April 10, 2007. His sire was Elusive Quality, who raced for Darley, owned by Sheikh Mohammed bin Rashid Al Maktoum of Dubai. Elusive Quality also sired Smarty Jones, winner of the 2004 Kentucky Derby and Preakness Stakes and given the 2004 Eclipse Award for Outstanding Three-Year-Old Male Horse. Demonstrative's dam was Loving Pride, who was sired by Quiet American, winner of the 1990 NYRA Mile and the San Diego Handicap. Demonstrative was bred by at Gainsborough Farm and was initially owned by Sheikh Mohammed until July 2010, then by Mrs. George L Ohrstrom Jr. of Aiken, South Carolina.

Demonstrative was sent to England in 2008 to train, and his six-year career began there in 2009, when he competed in eleven races with one win, three seconds, two thirds and £9,534 ($15,274). He was purchased for about $50,000 at the Tattersalls Sales in England for Mrs. Ohrstrom by Richard Valentine, who would become his trainer in America. Demonstrative competed in his first American race in a Maiden Special Weight contest that was 2⅛ miles over fences at Middleburg.

The race was held on October 3, 2010, and Demonstrative was ridden by Matthew McCarron, who guided the gelding to a win in a time of 4:06.40. Demonstrative raced in Camden, South Carolina, on

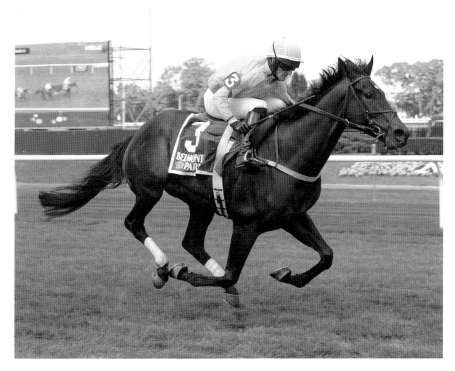

Demonstrative winning the 2014 Lonesome Glory Handicap. *Courtesy of Adam Coglianese.*

November 17 in the Colonial Cup Hurdle Stakes (G1), with McCarron in the irons again. He ran in the back of the field for most of the race. Then, just before the last jump, he moved to the outside, as there was no room for him on the inside. He cleared the last jump in ninth place. Demonstrative passed eight other horses in the stretch to win the 2¾-mile race in a time of 5:15.80.

Demonstrative's 2011 racing season saw him win twice in eight starts. In his 2012 racing season, he won three races in seven starts, taking his second Colonial Cup Hurdle Stakes (G1) and the New York Turf Writers Cup Steeplechase Handicap (G1). The 2013 season was not as successful, with only one win in five starts: the Calvin Houghland Iroquois Hurdle Stakes (G1) at Percy Warner Park in Nashville, Tennessee. The race, three miles over hurdles, was run on May 11. Demonstrative's main competition in this race was Divine Fortune, owned by Bill Pape. Demonstrative was in sixth place for the first two miles, and Divine Fortune stayed just in front of him. Demonstrative moved to second, just

behind Divine Fortune, at the top of the stretch, then caught her just before the finish line and won by a neck in a time of 5:42.40.

Demonstrative would have an outstanding 2014 season, winning three consecutive Grade 1 stakes: the New York Turf Writers Cup at Saratoga, the Lonesome Glory Handicap at Belmont Park and the Grand National Steeplechase at Far Hills, New Jersey. He was ridden in all of his races by Robbie Walsh, an Irishman who was rated fifth in the number of races won by a rider and second in the amount of money won in 2014.

The New York Turf Writers Cup took place on August 25. Walsh held Demonstrative just off the pace in third place during most of the 2⅜-mile race. After passing the 2-mile mark, Demonstrative made his move, cleared the last jump and passed Pleasant Woodman, who had led from the start. He was in the lead by a head when Barnstorming, owned and trained by Jonathan E. Sheppard, made a charge in the stretch. But Barnstorming couldn't catch Demonstrative, who held on to the lead, winning in a time of 4:34.78.

Divine Fortune and Barnstorming, both of which had finished second behind Demonstrative in previous contests, would face him once again, this time in the Lonesome Glory Handicap on September 18. The course was 2½ miles over hurdles. Divine Fortune was favored to win. Divine Fortune, the 2013 Steeplechase Champion, led for most of the race, until the two-mile mark, when Demonstrative passed him on the last turn, winning in a time of 5:01.70. Divine Fortune fell to fourth before reaching the last hurdle, where he fell and left the course uninjured. Barnstorming, in second place early in the race, finished fifth. The win gave Demonstrative two straight Grade 1 wins. He would go for a third win at the Grand National Steeplechase on October 18.

The Grand National, a 2⅝-mile hurdle stakes over National Fences, had decided the 2011, 2012 and 2013 Eclipse Award winners. Divine Fortune and Barnstorming would once again try to take victory and a possible Eclipse Award from Demonstrative. Demonstrative stayed with the pace from the beginning, content to stay in third for the first mile, right behind Divine Fortune, who maintained the lead until the 2-mile mark. Demonstrative took the lead from Divine Fortune with three fences left in the race and never relinquished it, winning in a time of 5:19.00. Divine Fortune finished a strong second. Barnstorming wasn't a real factor in the race, finishing fourth.

Demonstrative would end his 2014 season with a third-place finish in the Colonial Cup in Camden, South Carolina. He wrapped up his 2014 season with three wins in six starts, with one second, one third and $362,500 in earnings. He won an Eclipse Award as the 2014 Champion Steeplechase Horse. Demonstrative raced in 2015, winning the Calvin Houghland Iroquois Hurdle Stakes for a second time. He would race three times in 2016 without a win and was retired after finishing eighth in the A.P. Smithwick Memorial Steeplechase Stakes (G1) in Saratoga.

Demonstrative's career record was forty-eight starts with fourteen wins (eight graded stakes), eight seconds, eight thirds and career earnings of $971,324. He was elected to the Aiken Thoroughbred Racing Hall of Fame on March 15, 2015.

Devil Diver

Devil Diver, a bay horse, was foaled in Kentucky in 1939. His sire was St. Germans, a multiple British stakes winner, second-place finisher in the 1924 English Derby and leading sire of 1931. Devil Diver's dam was Dabchick, whose sire was Royal Minstrel. Devil Diver was bred by Greentree Stud and owned by Greentree Stable. He was trained by John M. Gaver Sr.

Devil Diver's racing career began in 1941. He won his first race on August 8, a maiden race for two-year-old colts and geldings at Saratoga Race Course. He would go on to win three graded stakes races, including the Sanford Stakes, Hopeful Stakes and the Breeders' Futurity. He finished the year with four wins (three graded stakes) in twelve starts, seven seconds, one third and $65,359 in earnings. His sophomore year was somewhat of a disappointment, with a sixth-place finish in the Kentucky Derby and an eighth-place finish in the Preakness Stakes. The highlight of his 1942 season was a win in the Phoenix Handicap over Whirlaway, the 1941 Triple Crown winner. He finished the year with four wins in nine starts, one second, one third and earnings of $10,535.

Devil Diver's 1943 would be a much better year for the Greentree colt. He captured four graded stakes, winning the Toboggan Handicap (G3), the Metropolitan Handicap (G1), the Carter Handicap (G1) and the Brooklyn Handicap (G1). His stablemate Shut Out, winner of the 1942

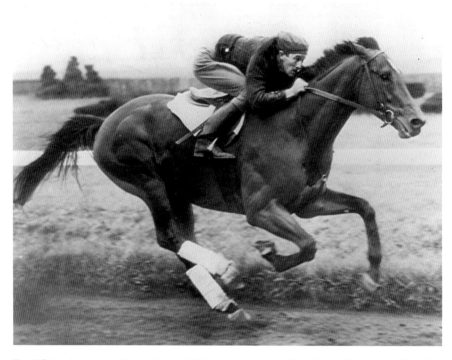

Devil Diver breezing at Keeneland, 1942, rider unknown. *Aiken Thoroughbred Racing Hall of Fame Archives.*

Kentucky Derby and Belmont Stakes, was also entered in the Toboggan, the Metropolitan and the Brooklyn but was never a real factor in any of the races, his best finish being fourth in the Brooklyn Handicap.

George Woolf, of Seabiscuit fame, rode the Greentree colt in the fiftieth running of the Toboggan Handicap on May 10 at Belmont Park. The twelve-horse field included Louis B. Mayer's Thumbs Up. Devil Diver worked his way from the back of the field to third place by the top of the stretch and drove past Thumbs Up in the stretch to win in a time of 1:10 in the three-quarter-mile race. The win was Devil Diver's first victory in four starts. Woolf rode Devil Diver in the Metropolitan Handicap on May 16 at Belmont Park. The race featured an eleven-horse field that once again included Thumbs Up. Devil Diver broke well to lead at the start of the one-mile race. When Woolf moved him to the outside to give the colt more running room, he fell back to fifth but was still within a half-length of the leaders, Mrs. Tilyou Christopher's Doublrab and Mayer's Thumbs Up. Entering the stretch, Thumbs Up

had taken the lead from Doublrab, but Devil Diver was on the heels of both horses. Under the encouragement of Woolf, he passed both horses near the finish, winning by 1¼ lengths over Thumbs Up in a time of 1:36 3/5. Doublrab finished a disappointing sixth.

The Brooklyn Handicap, held on June 26 at Aqueduct, was a 1¼-mile race. Devil Diver was the favorite in the nine-horse field to win the fifty-fifth running of this race. George Woolf was back up on a Greentree horse, this time on Shut Out. Steve Brooks, who had ridden Riverland to a victory over Devil Diver in the 1943 Excelsior Stakes earlier in the year, got the call to ride the Greentree colt. Brooks kept Devil Diver in the middle of the field during most of the race, content to stay just behind leaders Don Bingo from Bingling Stable (owned by entertainer Bing Crosby and close friend Lindsay Howard) and Market Wise, owned by Marise Farm. Devil Diver was leading by half a length in the stretch. Under urging from Brooks, he was able to win by a length and a half over Market Wise, who came in second. Devil Diver finished his 1943 season with four wins (four graded stakes) in nine starts, one second and earnings of $48,900. He was named the 1943 Champion Older Male.

Devil Diver would experience another great season in 1944, winning seven races in twelve starts, including five graded stakes races. He won the Paumonok Handicap (G3) on April 8 at Jamaica, taking the ¾-mile contest over Belair Stud's Apache in a time of 1:11 1/5. He was ridden in this race by Ted Atkinson. Eddie Arcaro rode Devil Diver in his next contest, the Toboggan Handicap (G3) on May 8. Arcaro guided the colt to win the Toboggan for a second time, beating Woolford Farm's Signator by a little more than a length in a time of 1:12 3/5.

Ted Atkinson was back in the irons on Devil Diver in the Metropolitan Handicap (G1) at Belmont on May 13 in an attempt to win the race for a second straight year. There were seven horses in the field, with Devil Diver the favorite. He broke well from the gate but was behind William Ziegler Jr.'s Wait a Bit, who led most of the race through the stretch. Wait a Bit was caught by a quick-charging Devil Diver in the stretch. Alwin C. Ernst's Alquest also passed Wait a Bit in the stretch and came up quickly to challenge Devil Diver. The Greentree colt was able to withstand the challenge because of a strong-hand ride by Ted Atkinson, winning by 1½ lengths in a time of 1:35 4/5. Devil Diver was the first and only horse to win both the Toboggan and Metropolitan Handicaps in successive years.

Devil Diver ended his 1944 season with twelve starts, seven wins (five graded stakes races), one second, one third and $72,005 in winnings. He was named the 1944 Champion Older Male.

In the Greentree colt's last season, 1945, he won three races: the Paumonok Handicap (G3) for the second year in a row, the Suburban Handicap and the Metropolitan Handicap for the third straight year. His string of three successive wins in the Metropolitan Handicap is a record that still stands today. Devil Diver was retired on August 2, 1945, after aggravating an old foot injury he had received in the 1941 Pimlico Futurity. Devil Diver's career record was forty-seven starts, with twenty-two wins (seventeen graded stakes), twelve seconds, three thirds and career earnings of $261,064. Devil Diver sired eighteen stakes winners and died in 1961 at the age of twenty-two. He was buried in Lexington, Kentucky, at Magdalena Farm, formally known as Stallion Station and Pillar Stud.

He was elected to the Aiken Thoroughbred Racing Hall of Fame on January 23, 1977.

ELKRIDGE

This brown gelding was foaled in Maryland in 1938. His sire was Mate, and his dam was Best by Test. Elkridge was bred by Joe F. Flanagan and owned by Thomas Hitchcock Sr. (1860–1941). He had an eleven-year racing career as a steeplechase horse. Elkridge won the first race in which he was entered, the Tourist Steeplechase Handicap on September 24 at Belmont Park. This was one of the last times Hitchcock saw one of his horses run, as he died on September 29, 1941. In the wake of Hitchcock's death, Elkridge did not race again in 1941. Hitchcock's horses were sold at auction on November 10 at Pimlico Race Course, where Kent Miller purchased Elkridge for $7,000. Miller was also Elkridge's trainer.

Elkridge would compete twenty times in 1942, winning seven of his races. The North American Steeplechase Handicap was held on August 15 at Saratoga. Five horses competed in this two-mile race, with Jimmy Penrod riding Elkridge. His main competition was from a horse named The Beak, owned by Mrs. Ambrose Clark. The Beak was in the lead from the start. Elkridge, in fourth at the beginning of the race, moved up to second at the

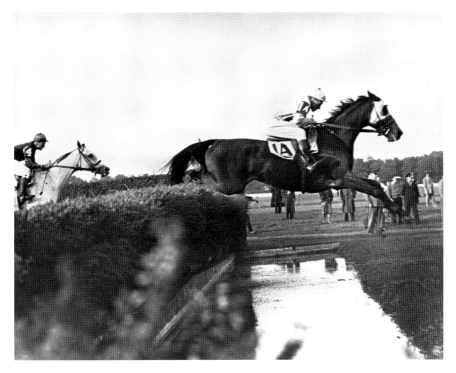

Elkridge at the 1946 American Grand National Steeplechase Handicap. *Aiken Thoroughbred Racing Hall of Fame Archives.*

half-mile mark and held that position to the stretch, where he caught up with The Beak. Elkridge passed and pulled away from the field and won by eight lengths in a time 4:19 3/5. Clark's horse finished second.

The Broad Hollow Steeplechase Handicap was held on September 23 at Belmont Park. Elkridge's rider was J.S. Harrison. There were five horses in the field for the 2-mile race, including Montpelier Stable's Rouge Dragon, which would later be named the 1944 U.S. Champion Steeplechase Horse. Mrs. Ambrose Clark's Lovely Night took an early lead but relinquished it to Rouge Dragon at the ½-mile mark. Rouge Dragon held the lead until the 1½-mile mark, when Lovely Night regained first place. Elkridge cleared the last hedge, caught Lovely Night in the stretch and pulled away for a four-length win in a time of 3:48 3/5. Lovely Night finished second, and Rouge Dragon finished third.

Elkridge also won the Indian River Steeplechase Handicap, the Governor Ogle Steeplechase Handicap, the Battleship Steeplechase

Handicap and the Manly Steeplechase Handicap, his last win of the year. He ended the 1942 season with seven wins in twenty starts, five seconds, one third and $28,130 in earnings. He was the top steeplechase horse in the country in terms of yearly winnings. He was named the 1942 Champion Steeplechase Horse.

Elkridge's record for 1943–45 was nine wins in forty-one starts, with four seconds, six thirds and in $53,265 in earnings. He won the 1943 North American and Harbor Hill Steeplechase Handicaps; the 1944 Shillelah, Saratoga and Broad Hollow Steeplechase Handicaps; and the 1945 Battleship, Indian River and Charles L. Appleton Steeplechase Handicaps.

The year 1946 would be a good one for Elkridge, winning his third North American Steeplechase Handicap and the Grand National Steeplechase Handicap. The former race was held at Saratoga on August 16. There were only four horses in the field for the two-mile race, two of which, Last and Boojum II, were owned by Mrs. Ambrose Clark. Frank D. "Dooley" Adams got the call to be Elkridge's rider. Last was in first place from the start of the race until the fifteenth hurdle. Elkridge was in second place from the fourth hurdle to the fifteenth hurdle, where he caught Last and took over first by a length. He pulled away in the stretch, beating Last by five lengths and Boojum II by nine lengths. His winning time was 4:14 4/5. Gadabout, owned by K.R. Marshall, fell at the twelfth hurdle and did not finish the race. Elkridge became the second three-time winner of this event.

The Grand National Steeplechase was held on October 3 at Belmont Park. Elkridge had tried two other times, in 1943 and 1944, to win this prestigious race, but came up short, finishing third both times. There was a ten-horse field for this three-mile, nineteen-hurdle race. Emmett Roberts was in the irons for Elkridge. Notable horses competing against Elkridge were Mrs. Esther duPont Weir's Burma Road and Galatic, Mrs. Ambrose Clark's Raylywn and Great Flare and Montpelier Stable's Rouge Dragon. Roberts kept Elkridge off the pace, in fourth place, behind leaders Rouge Dragon, Galatic and Raylywn. Tragedy struck at the tenth hurdle, when Rouge Dragon fell, breaking his shoulder. The horse had to be humanely euthanized. Roberts guided Elkridge to first place after clearing the fifteenth hurdle, and he maintained that spot after the nineteenth hurdle and to the finish for the win in a time of 5:48 4/5. Elkridge beat second-place finisher

Burma Road by five lengths and was nine lengths ahead of Mrs. C.E. Adams's Refulgo. Elkridge would finish the 1946 season with three wins in nine starts, two seconds, one third and $35,285 in earnings. He was named the 1946 Champion Steeplechase Horse.

Elkridge would race for four more seasons (1948–51), winning eleven races in fifty-two starts with seven seconds, seven thirds and $113,000 in earnings. He would win the 1947 Glendale and Lion Heart Steeplechase Handicaps; the 1948 Shillelah, Indian River and North American Steeplechase Handicaps; the 1949 Georgetown, Indian River and Meadow Brook Steeplechase Handicaps; and the 1950 Georgetown, Saratoga and Indian River Steeplechase Handicaps. Kent Miller retired Elkridge at the end of 1951 to his farm, but the horse wasn't happy there. He did not want to eat and was losing weight. Miller made the decision to bring Elkridge back to the track as a stable pony. The change put the former champion back in good spirits. Elkridge helped train younger stablemates in the fine art of steeplechase.

Elkridge's career record was 123 starts with thirty-one wins (thirteen graded stakes), eighteen seconds, fifteen thirds and career earnings of $230,680. Elkridge died in 1961 at age twenty-three. He was elected to the National Racing Hall of Fame in Saratoga, New York, in 1966. He was elected to the Aiken Thoroughbred Racing Hall of Fame on January 23, 1977.

FORTY NINER

Forty Niner, a chestnut horse, was foaled at Claiborne Farm in Kentucky on May 11, 1985. His sire was Mr. Prospector, winner of the 1974 Whirlaway Handicap. Mr. Prospector has the distinction of siring one winner of each of the Triple Crown races: 2000 Kentucky Derby winner, Fusaichi Pegasus; 1985 Preakness Stakes winner, Tank's Prospect; and 1982 Belmont Stakes winner, Conquistador Cielo. Forty Niner's dam was File, who was sired by Tom Rolfe, winner of the 1965 Preakness Stakes and the 1965 American Champion Three-Year-Old Male Horse. Forty Niner was owned by Claiborne Farm near Paris, Kentucky. Claiborne, established in 1910 by Arthur B. Hancock, has been operated by

members of his family ever since. Racing historian Edward L. Bowen considers Claiborne Farm one of the most influential American breeding operations. Forty Niner was trained by National Racing Hall of Fame member Woody Stephens.

Forty Niner began his two-year racing career in 1987, winning the very first race in which he was entered. It was a Maiden Special Weight race held on July 17 at Belmont Park. Forty Niner won the six-furlong contest in a time of 1:11.60, beating Dynaformer by 3¼ lengths. Eddie Maple, his jockey for this race, would ride Forty Niner in all of his 1987 races. The Claiborne colt was entered in the six-furlong Saratoga Special Stakes on August 7, finishing six lengths behind the winner, Crusader Sword. This would be the last race he would lose in 1987.

The Claiborne colt was entered in the six-furlong Sanford Stakes (G2) at Saratoga on August 19. Once Wild, the favorite in the race, had built a 4-length lead after the half-mile mark. Headed into the stretch, Maple guided Forty Niner to the outside for better footing on a sloppy track, and the

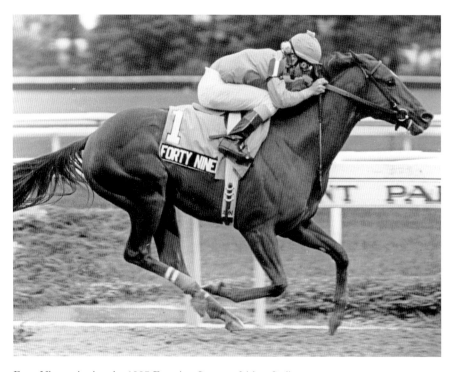

Forty Niner winning the 1987 Futurity. *Courtesy of Adam Coglianese.*

colt exploded past Once Wild, winning by 3½ lengths in a time of 1:10.00. Next, he was entered in the seven-furlong Futurity Stakes (G1) at Saratoga on September 20. He won in a time of 1:22.60, finishing 3 lengths in front of Tsarbaby and 5¼ lengths in front of Crusader Sword.

The Champagne Stakes (G1), run on October 17 at Belmont Park, was a one-mile race with an eleven-horse field. Forty Niner started well but was kept behind the pace, in third place, waiting for a chance to move up. Maple guided him into first at the top of the stretch, and he never looked back, winning in a time of 1:36.80. He was 4¼ lengths ahead of second-place Parlay Me and 5½ lengths ahead of third-place Tejano, who had been the favorite to win the race.

The Breeders' Futurity (G2) was run on October 30 at Keeneland. This race, 1¹⁄₁₆ miles, would be Forty Niner's first race around two turns. He was the favorite to win. The Claiborne colt took the lead at the first turn and wasn't seriously challenged by the other horses until the stretch, when Hey Pat caught him and got by Forty Niner by half a neck. Maple urged his horse to retake the lead, and he did so at the finish line, ending the race in a photo finish. Forty Niner won by a nose over Hey Pat in a time of 1:43.80. Third-place finisher Sea Tek was 3¾ lengths behind Forty Niner. This was his last race of the year, and he was given some time to rest for the 1988 season. He ended his freshman season with five wins (four graded stakes) in six starts and $634,908 in winnings. He won an Eclipse Award as the 1987 Champion Two-Year-Old Colt.

Forty Niner's final season would be a successful one, with five stakes wins: the Travers (G1), the Haskell Invitational (G1), the Fountain of Youth (G3), the Lafayette Stakes and the NRYA Mile Handicap. He would finish second in the Kentucky Derby (G1) being beaten by Winning Colors. His 1988 season resulted in six wins (five graded stakes) in thirteen starts, five seconds and earnings of $2,091,092. He was retired after a fourth-place finished in the Breeders' Cup Classic at Churchill Downs. Forty Niner's career record was nineteen starts with eleven wins (nine graded stakes), five seconds, three thirds and career earnings of $2,726,000. He was sent to stud at Claiborne and was North America's leading freshman sire in 1992.

Forty Niner was bought for $10 million by the Japan Racing Association for stud duty at the Japan Bloodhorse Breeders' Association's Shizunai Stallion Station in the summer of 1995. He was the third-leading sire by U.S. earnings in 1996. Forty Niner sired Distorted Humor, winner of the

1998 Churchill Downs Stakes and Commonwealth Breeders' Cup Stakes, and Coronado's Quest, winner of the 1998 Travers Stakes and Wood Memorial. He also sired 1996 Belmont Stakes winner Editor's Note. He is the grandsire of 2003 Kentucky Derby winner, Funny Cide, and the great-grandsire, through Distorted Humor, of 2012 Kentucky Derby winner, I'll Have Another. Forty Niner was pensioned in 2007 at Shizunai Stallion Station. He was elected to the Aiken Thoroughbred Racing Hall of Fame on March 20, 1988.

GALLORETTE

Gallorette, a chestnut mare, was foaled in Maryland in 1942. Her sire was Challenger II, a British Thoroughbred racehorse who became a leading sire in North America. Her dam was Gallette, who was purchased by Preston M. Burch (1884–1978) because of her highly successful sire, Sir Gallahad III, who was named the U.S. Champion Sire four times. He bred her to William L Brann's stallion Challenger II. Brann entered into an agreement with Burch that they would send Gallette to his stallion (who had sired Preakness winner Challedon), and then each would own her foals, the first one to Brann, then one to Burch and so on. Gallette's first foal, Gallorette, went to Brann. She was trained by Edward A. Christmas (1903–69).

Gallorette had a six-year race career that began in 1944. Her first win came on September 20 at Laurel Park in a 5½-furlong Maiden Allowance Race. She would go on to win The Morgil at Laurel Park in September and also at Laurel Park, an allowance race, on October 9. She finished her freshman season with three wins in eight starts, with three seconds, two thirds and $7,950. Her sophomore season would see her win five times in thirteen starts, with two seconds, one third and $94,300 in earnings. She had major wins in the Acorn Stakes, the Delaware Oaks, the Pimlico Oaks and the Empire City Stakes.

Gallorette had an outstanding year in 1946, winning the Metropolitan, Brooklyn, Bay Shore and Beldame Handicaps. The Metropolitan Handicap was held at Belmont Park on May 11. It was a one-mile race with fourteen entries. Gallorette was ridden by twenty-year-old Job Dean Jessop, who was named the 1945 United States Champion Jockey, with 290 wins. Jessop, per

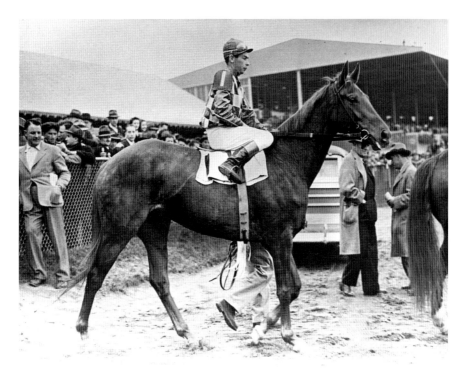

Gallorette at the 1947 Beldame Handicap. *Aiken Thoroughbred Racing Hall of Fame Archives.*

instructions from Gallorette's trainer, would keep her toward the back of the field. She was eleventh at the one-quarter mark and eighth at the one-half mark, three lengths behind the leader at the time, Polynesian. Gallorette had moved up to fifth at the three-fourths mark. Once she hit the stretch, she closed quickly and took the lead. Gallorette, Sirde (owned by Ada L. Rice) and First Fiddle (owned by Mrs. Edward Mulrenan) were nose to nose as they came to the wire in a three-way photo finish. After track officials reviewed the photo, it was determined that Gallorette had won by the slimmest of margins, in a time of 1:37. Sirde came in second, and First Fiddle took third.

The Brooklyn Handicap at Aqueduct was held on June 22. Jessop was in the irons again for Gallorette. The race, 1¼ miles long, had a field of eight, with Ethel D. Jacobs's Stymie the favorite to win. Stymie and Gallorette started well from the gate and were in seventh and eighth place, respectively. Gallorette moved up to fourth at the ½-mile mark, 1 length behind the leader, Helioptic. Stymie was still in eighth. Jessop guided her to the outside. At the top of the stretch, she was in second

place, 1½ lengths behind Helioptic. Gallorette took the lead from Helioptic, and neither were aware that a fast-moving Stymie was passing horse after horse in the bend. Early in the stretch, Stymie had passed Helioptic for second and was next to Gallorette. The mare battled the 1945 U.S. Champion Handicap Horse for the lead all the way down the stretch, with Gallorette finally getting in front and winning by a neck in a time of 2:05. Helioptic finished third. Gallorette's 1946 season ended with six wins in eighteen starts, five seconds, two thirds and $159,160. She was named the 1946 Champion Handicap Female Horse.

Gallorette would race two more years, winning the 1947 and 1948 Wilson Stakes, the 1947 Carter Handicap, the 1947 Queens County Handicap and the 1948 Whitney Stakes. She was retired with a career record of twenty-one wins in seventy-two starts with twenty seconds, thirteen thirds and $445,535 in winnings.

Gallorette's owner, William L. Brann, sold her to Marie A. Moore of High Hope Farm, The Plains, Virginia. She was retired in December 1948 to become a broodmare. Gallorette was humanly euthanized after injuring a hind leg on August 11, 1959, at High Hope Farm. She was inducted into the National Museum of Racing Hall of Fame in 1962. She was elected to the Aiken Thoroughbred Racing Hall of Fame on January 23, 1977.

GAMELY

Gamely, a bay mare, was bred and foaled at Claiborne Farm outside of Paris, Kentucky, on February 10, 1964. Her sire was Bold Ruler, who also sired Secretariat. Her grandsire was Nasrulla, who was bred in Ireland and trained in the United Kingdom before becoming a champion sire in both Europe and North America. Her dam was Gambetta, whose grandsire was My Babu, the Leading Juvenile Sire in 1960. My Babu was also the grandsire of National Racing Hall of Fame members Precisionist, Damascus and, in 1980, Gamely. Her owner was William Haggin Perry, whose feelings for his horse was reflected in the name of his breeding operation: The Gamely Corporation. She was trained by National Racing Hall of Fame member James W. Maloney (1909–1984).

Gamely's racing career began in 1967. She recorded her first win on June 23 in a seven-furlong allowance race at Hollywood Park for three-year-old fillies. Her next win came on July 3 in the Princess Stakes (G2) at Hollywood Park. This race, 1$\frac{1}{16}$ miles, had nine contestants. Gamely, ridden by hall of fame jockey Willie Shoemaker, broke well from the gate and was in fifth place coming to the one-quarter pole when she began to move up in the field. Approaching the $\frac{1}{2}$ mile mark, she was in third place and half a length behind the leader, Fish House, owned by C.V. Whitney. Gamely passed second-place horse Native Honey at the three-quarters mark and then blew past Fish House in the stretch to win by 2$\frac{1}{4}$ lengths in a time of 1:42 2/5.

Gamely was entered in the Test Stakes (G1, Division 1) on August 3 at Saratoga. There were ten horses in the field for the seven-furlong contest. Rokeby Stable's No Kidding was chosen as the favorite to win. Gamely and rider Eddie Belmonte weren't kidding as they came to the last turn, blowing by the leaders and winning by six lengths over the second-place finisher, Wageko, and the favorite, No Kidding, which finished third. Gamely set a new track record for seven furlongs, with a time of 1:21 4/5.

The 1$\frac{1}{4}$-mile Alabama Stakes (G1) was scheduled for August 12 at Saratoga, with thirteen horses in the field. Gamely, coming off a spectacular win in the Test Stakes (G1), was the odds-on favorite. Willie Shoemaker got the call to ride Gamely, running against her stablemate, Princessnesian, as well as Treacherous, owned by Lazy F Ranch. She was caught in the bulk of the field in the first part of the race, but Shoemaker was able to guide her into fifth place going into the second turn by coming to the outside. She moved into second in the backstretch, passing Silver True. Coming into the stretch, Gamely was leading, with Treacherous right beside her. In the stretch, Gamely took off and pulled away from Treacherous, winning by two lengths in a time of 2:03 1/2, equaling the stakes record. Gamely's first year of racing resulted in fourteen starts with four (three graded stakes) wins, three seconds, three thirds and earnings of $117,617. She was named the 1967 Champion Three-Year-Old Filly.

Gamely had a very successful season in 1968, winning six graded stakes. The first victory came in the Santa Maria Handicap (G2) on January 27 at Santa Anita Park. The favorite going in to the 1$\frac{1}{16}$-mile race, Gamely was ridden by Manuel Ycaza, taking the place of an injured Willie Shoemaker. Gamely got out of the gate cleanly and stayed on the outside of the middle

of the field. She got the lead in the stretch and beat Princessnesian by three-fourths of a length in a time of 1:43 3/5.

Gamely and Princessnesian would meet up again in the Santa Margarita Handicap (G1) on February 17 at Santa Anita. The race included some controversy between the riders of the stablemates. Gamely didn't break from the gate well and ended up on the outside and at the back of the field. Fred Astaire's Sharp Curve had the early lead into the backstretch, but by the second turn, she had lost the lead, with Gamely in second. Turning into the stretch and getting the lead, Gamely stuck her toes into the dirt as if to stop and then drifted out in front of Princessnesian, who was closing fast. The two stablemates battled each other down to the wire, with Gamely winning the 1⅛-mile contest by a nose in a time of 1:49.00. Princessnesian's jockey, Laffit Pincay, was visibly upset after the race, saying that Gamely had interfered with Princessnesian in the stretch and cost her the race. Ycaza said that, while it probably did bother Princessnesian when Gamely drifted in front of her, it didn't affect the outcome of the race. Pincay wanted to

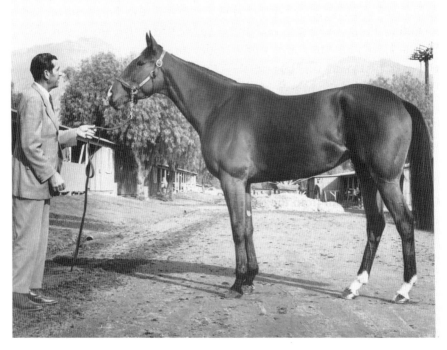

Gamely and trainer James W. Maloney at Santa Anita, 1969. *Aiken Thoroughbred Racing Hall of Fame Archives.*

claim a foul, but William Haggin Perry, who owned both horses, was able to talk him out of it.

Gamely would compete at Hollywood Park for several months, winning the Wilshire Handicap (G3) on May 1, the Inglewood Handicap on June 8 and the Vanity Handicap (G1) on July 29. She competed in the Hollywood Gold Cup on July 13, finishing seventh. Her stablemate, Princessnesian, finally beat her, winning the 1¼-mile race in a time of 1:59 4/5. Gamely's habit of drifting in front of other horses in the stretch cost her the Diana Handicap (G1) at Saratoga on August 19. Gamely finished a neck in front of Rokeby Stables' Green Glade, but she was set back to second after the stewards concluded she had impeded Green Glade when she drifted in front of her. Green Glade was declared the winner. Gamely finished her 1968 season with seven wins (six graded wins) in fourteen starts, three seconds, two thirds and $282,742 in earnings. She was named the 1968 Champion Handicap Mare.

Gamely's final season would see with four graded stakes wins. Her first race of the year was the Santa Monica Handicap (G2) on January 21 at Santa Anita. This was a seven-furlong race with five horses in the field, including Princessnesian. Gamely broke well from the start, and jockey Wayne Harris kept her close to the leader and pacesetter, Time to Leave. Harris kept Gamely in second the entire race until the final turn into the stretch, when he urged her, by hand, to overtake the leader. Gamely responded and pulled ahead, winning by three-fourths of a length over Time to Leave in a time of 1:23 3/5. Princessnesian finished fourth and wasn't a factor in the race.

The Diana Handicap (G1) at Saratoga, a 1⅛-mile race, was held on August 18. Eddie Belmonte got the call to ride Gamely in the five-horse field. Gamely broke clean from the gate and took the early lead and held it from start to finish, winning in a time of 1:49 3/5, 2½ lengths in front of second-place finisher, Christiana Stables' Obeah. There was a scare after the race, when Gamely took a bad step and came up lame. The track veterinarian, Dr. Manuel Gilman, examined her after the race, but he found no injury.

Gamely's last win of the year came in the Beldame Stakes (G1) on September 13. Her main competition in the 1⅛-mile race was expected to come from Shuvee, owned by Mrs. Whitney Stone. Gamely was favored to win in the five-horse field. Laffit Pincay was in the irons for this race. Gamely broke well from the gate and was in second coming to the one-

quarter pole. Approaching the three-quarters pole, she took the lead and maintained it, winning by three lengths in a time of 1:45.1. Amerigo Lady finished second, and Shuvee came in third. Gamely finished her 1969 season with five wins (four graded) in thirteen starts, with three seconds, one third and $174,602 in earnings. She was named the 1969 Champion Older Mare and was retired that year.

Gamely's career record was forty-one starts with sixteen wins (thirteen graded stakes), nine seconds, six thirds and career earnings of $574,961. She died in 1975 at age eleven, five days after she gave birth to her second foal. She was elected to the Aiken Thoroughbred Racing Hall of Fame on January 23, 1977, and the National Racing Hall of Fame in 1980.

HAWAII

This dark bay horse was foaled on August 1, 1964, in South Africa. His sire was Utrillo II, who was foaled in Italy, and his dam was Ethane, foaled in South Africa. He was bred by Archie Dell's Platberg Stud in South Africa. Hawaii was owned by Charles W. Engelhard Jr., owner of Cragwood Stable. Engelhard (1917–1971) was an American businessman who controlled an international mining and metals conglomerate, and he was a major owner of Thoroughbred horses. Hawaii was trained in the United States by National Racing Hall of Fame member MacKenzie Miller (1921–2010).

He began his racing career in South Africa. In that country, he won the following major races: the 1966 African Breeders' Plate, the 1967 Chairman's Handicap, the 1967 South African Guineas, the 1967 Clairwood Winter Handicap, the 1967 Cape Mellow–Good Guineas and the 1968 Transvaal Spring Champion Stakes. He was named the 1966 South African Champion Two-Year-Old Male and the 1967 South African Champion Three-Year-Old Male.

He was sent to the United States in December 1968. After spending the required sixty days in quarantine on arrival, Hawaii was sent to Aiken Training Track in February 1969. Hawaii's first race in the United States was on June 3 at Belmont Park in the Montauk Club, a seven-furlong race on the turf. He won in a time of 1:24.40. His next race was at the Stars and Stripes Handicap (G3) at Arlington Park on July 4. For this fifteen-horse,

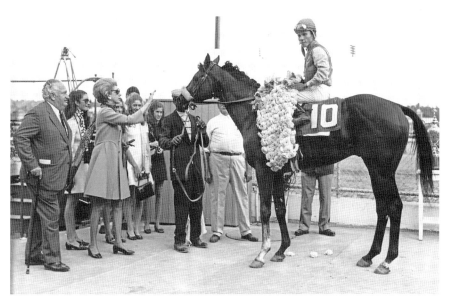

Hawaii after winning the 1969 United Nations Handicap. *Aiken Thoroughbred Racing Hall of Fame Archives.*

1⅛-mile turf race, Manuel Ycaza was his rider. Hawaii stayed close to the leaders the entire race, being in fourth place for most of the race. Entering the stretch, he battled with Great Cohoes for the win. Hawaii was able to pass him just before the wire, winning by three-fourths of a length and in a time of 1:49 4/5.

Hawaii would be part of a dual win for Cragwood Stable in the Bernard Baruch Handicap at Saratoga on August 6. The 1¹⁄₁₆-mile race was split into two divisions due to the number of horses entered. Manuel Ycaza was in the irons for Gamely, the even-money favorite to win the second division. Hawaii pulled away in the stretch to win by four lengths in a time of 1:42. Division 1 was won by Hawaii's stablemate Larceny Kid.

The United Nations Handicap was held on September 10 at the now-defunct Atlantic City Race Course. Hawaii was ridden by Jorge Velasquez in the 1³⁄₁₆-mile turf race. Velasquez kept Hawaii in the back of the field in eighth place, behind leaders Rising Market and Addy Boy. When he approached the ½-mile mark, Velasquez began moving Hawaii up the field; at the ¾-mile mark, he was in second place. Hawaii stayed in that position

until the stretch, where he passed the new leader, North Flight. Hawaii won by half a length in front of North Flight in a time of 2:00 3/5.

His last win of the year came in the 1½ mile Man o' War Stakes at Belmont Park on October 18. Velasquez got the call to ride Hawaii in the nine-horse field. He broke clean from the gate and stayed in fourth place for most of the race. Approaching the stretch, Hawaii was taken to the outside and, on entering the stretch, rapidly gained on the leader, North Flight. Entering the last furlong, Hawaii took the lead, winning by 2¼ lengths in a time of 2:27 1/5.

Hawaii finished his 1969 season with six wins (five graded stakes) in ten starts, one second, two thirds and $279,280 in earnings. He was named the 1969 Champion Grass Horse. Hawaii's career record, including in South Africa, was twenty-eight starts, with twenty-one wins (thirteen graded), two seconds, three thirds and career earnings of $371,292.

Hawaii went to stud at Claiborne, where he sired 116 offspring. His most notable offspring was the 1980 English Derby winner, Henbit. Hawaii died at Claiborne Farm in 1990 at age twenty-six and is buried in the farm's Marchmont division equine cemetery. He was elected to the Aiken Thoroughbred Racing Hall of Fame on January 23, 1977.

HEAVENLY CAUSE

Heavenly Cause, a gray mare, was foaled on May 22, 1978, in Maryland. Her sire was Grey Dawn, the 1964 French Champion Two-Year-Old Colt and 1990 leading broodmare sire in North America. Her dam was Lady Dulcinea, a granddaughter of Nearco, described as "one of the greatest racehorses of the Twentieth Century" and "one of the most important sires of the century." She was bred by Adele W. Paxson. Heavenly Cause was purchased by Jim and Eleanor Ryan, who raced her under the name of their Ryehill Farm. She was trained by National Racing Hall of Fame member Woody Stephens, who had a training base at the Aiken Training Track. Heavenly Cause began her two-year racing career in 1980 by winning the first race in which she was entered. Stephens entered her in a Maiden Special Weight race at Belmont Park. In the seven-furlong contest, Heavenly Cause beat Flying Zee Stable's Wayward Lass by nine lengths in a time of

1:24 2/5. She wouldn't win another race until September 8, the Marlboro Nursery Stakes, at the now-defunct Bowie Race Track in Maryland. This would be another seven-furlong race, and jockey Eddie Maple would ride her against six fillies. Heavenly Cause won by five lengths over Cavort in a time of 1:25.40.

The Frizette Stakes (G1) on October 5 at Belmont Park was her next win. She competed against seven other fillies, including Henryk de Kwiatkowski's De La Rose, another Aiken-trained horse. Laffit Pincay Jr. was in the irons for this race. Heavenly Cause broke well out of the gate and stayed in the middle of the field through the ¾ mark. Sweet Revenge, owned by William S. Farish III, was in the lead from the opening of the gate until one furlong from the finish. Pincay Jr. moved Heavenly Cause into second at the top of the stretch, 1½ lengths behind Sweet Revenge. Heavenly Cause took the lead with a furlong to go and beat Sweet Revenge by 1½ lengths in a time of 1:38.

Her final win of the year came in the Selima Stakes (G1) at Laurel Park on November 1. She was ridden again by Laffit Pincay Jr. After the start of

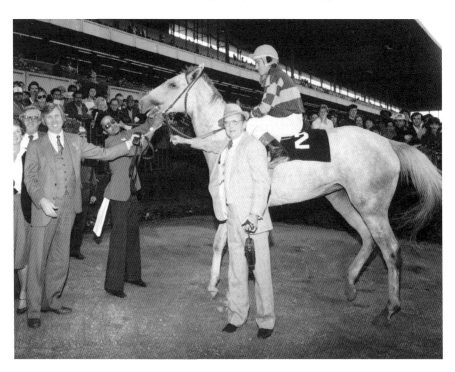

Heavenly Cause after winning the 1980 Frizette. *Aiken Thoroughbred Racing Hall of Fame Archives.*

the 1 1/16-mile race, Heavenly Cause was in second place through the 1/2-mile mark. She fell back to third momentarily when she was eased back to the rail but took the lead going into the stretch and pulled away from William S. Farish III's Rainbow Connection to win by 2 1/4 lengths in a time of 1:43 2/5. Heavenly Cause ended 1980 with four wins (three graded stakes) in nine starts, two seconds, one third and $269,819 in earnings. She won an Eclipse Award as the 1980 Champion Two-Year-Old Filly.

Heavenly Cause raced one more year, 1981, winning five races (four graded stakes) in fifteen starts, two seconds, one third and $352,662 in earnings. She would win the Acorn Stakes (G1), the Fantasy Stakes (G1), the Kentucky Oaks (G1) and the La Troienne Stakes. She was retired in December 1981 to Claiborne Farm in Kentucky. She produced twelve foals, all gray, suggesting that she was homozygous for the dominant gene that causes graying in horses. Heavenly Cause is the dam of Two Punch, who in turn sired champion sprinter Smoke Glacken. Christmas Past was sent to England in 1992 as a broodmare. Heavenly Cause was elected to the Aiken Thoroughbred Racing Hall of Fame on March 15, 1981.

KELSO

Kelso, a dark bay gelding, was foaled on April 4, 1957, at Claiborne Farm near Paris, Kentucky. His sire was Your Host, winner of the 1949 Del Mar Futurity and the 1950 Santa Anita Derby. His dam was Maid of Flight, whose sire was Count Fleet, the 1943 Triple Crown champion. Kelso was bred and owned by Allaire du Pont's Bohemia Stable. Kelso was trained by National Racing Hall of Fame member Carl Hanford (1916–2011). Bohemia Stable had a training base at the Aiken Training Track.

Kelso was named for Mrs. du Pont's friend Kelso Everett. A very temperamental horse, Kelso was hard to handle; because of this, du Pont had him gelded. Kelso's racing career began in 1959, when he won the first race he entered, a six-furlong allowance race at Atlantic City on September 4. He finished the year with one win in three starts, with two seconds and $3,380 in earnings. Little did Mrs. Du Pont or anyone else realize that his next racing season would be the start of something very special and spectacular.

Kelso would win eight races in nine starts in 1960. His wins included the Hawthorne Gold Cup Handicap, the Lawrence Realization, the Discovery Handicap, the Choice Stakes, Jerome Handicap and the Jockey Club Gold Cup. Kelso won eight consecutive graded stakes, but the highlight of the year was his performance in the Jockey Club race on October 29 at Aqueduct. Eddie Arcaro was in the irons for the 2-mile race. There were eight entries, with Gustave Ring's Don Poggio, winner of the Manhattan Handicap, expected to give Kelso the most competition. Kelso started the race cleanly. Arcaro kept him in check, maintaining third place behind Don Poggio and Tooth 'n' Nail, who had the lead. When the $1\frac{1}{2}$-mile mark had been reached, Don Poggio passed Tooth 'n' Nail for the lead and Kelso moved into second, just half a length behind Don Poggio. Cornelius V. Whitney's Dotted Swiss took over third, Cain Hoy Stable's Bald Eagle was in fourth and Tooth 'n' Nail dropped to fifth. Arcaro gave Kelso a couple of flicks with his whip, and the horse engaged into a higher speed and took over the lead in the stretch. He won the Gold Cup by $3\frac{1}{2}$ lengths in a time of 3:19 2/5, a new track and American record. Don Poggio finished second, and Bald Eagle passed Dotted Swiss to take third. Kelso's 1960 season ended with eight wins in nine starts and $293,310 in earnings. He was chosen the 1960 Champion Three-Year-Old Colt and the 1960 Horse of the Year.

Success continued for Kelso in 1961, when he would win seven races in nine starts. His wins included the Woodward Stakes, the Whitney Stakes, the Brooklyn Handicap, the Suburban Handicap, the Metropolitan Handicap and his second Jockey Club Gold Cup. The Woodward Stakes was his most commanding win of the year. The $1\frac{1}{4}$-mile contest at Belmont fielded five horses, including Mrs. Katherine Price's Carry Back, winner of the 1961 Kentucky Derby and Preakness Stakes. Divine Comedy, owned by Llangollen Farm and ridden by Willie Shoemaker, took the early lead, set the pace and held it until entering the stretch. Kelso, with Eddie Arcaro up, took the lead entering the stretch and began to increase his lead to eight lengths, winning in 2:00. Many felt that if Arcaro had forced Kelso to run at full speed, the horse could have been even faster. Divine Comedy finished second, and Carry Back finished third. Kelso's 1961 season ended with seven wins in nine starts with one second and $425,565 in earnings. He would be chosen the 1961 Champion Older Horse and the Horse of the Year for the second consecutive year.

Kelso's dominance in racing continued in 1962. His six wins included the Governor's Plate, the Stymie Handicap, the Woodward Stakes (second consecutive) and the Jockey Club Gold Cup (third consecutive). Kelso's bid for a third consecutive Jockey Gold Cup took place on October 18 at Belmont, with Ismael Valenzuela in the irons. There were two good stakes-winning horses competing against Kelso in this race. Nickel Boy, owned by Elmendorf Stable, had won the 1957 Marlboro Nursery Stakes, the 1960 New York Handicap and the 1961 Manhattan Handicap. Tutankhamen, owned by Greentree Stable, had won the 1963 Donn Handicap and the 1962 Manhattan Handicap. Tutankhamen took the early lead but quickly lost it to Troubadour, owned by Gustav Ring. Troubadour, ridden by Manuel Ycaza, would hold the lead to the one-mile mark. When Valenzuela guided Kelso around the last turn into the stretch, the gelding took control of the race, increasing his lead with every stride. Tutankhamen couldn't match Kelso's speed and finished fourth. Guadalcanal, owned by Mrs. Robert L. Dotter, moved up to second in the stretch, and Nickel Boy moved into third. When Kelso crossed the wire, he won in ten lengths. He ran the two-mile race in a time of 3:19 4/5, a new track record. Kelso ended the 1962 season with six wins in twelve starts, four seconds and $289,685 in earnings. Kelso was chosen the Champion Older Horse for the second consecutive year and Horse of the Year for the third consecutive year.

Although it is certainly a cliché, it could be said that Kelso was like a fine bottle of wine, getting better with age. In 1963, he won nine races, all of them stakes: the Aqueduct Stakes, the Seminole Handicap, the Nassau County Handicap, the Gulfstream Park Handicap, the John B. Campbell Handicap, the Whitney Stakes (for the second time), the Suburban Handicap (for the second time), the Woodward Stakes (third consecutive) and the Jockey Club Gold Cup (fourth consecutive). The Whitney Stakes was held on August 3. The 1⅛-mile race at Saratoga had six entries, including Guadalcanal, who had finished second to Kelso in the 1962 Jockey Gold Cup. Kelso made one of his legendary stretch runs after his rider, Ismael Valenzuela, maintained fourth place until the top of the stretch. Kelso won by 2½ lengths in a time of 1:50 2/5. Saidam, owned by Mrs. J. Deaver Alexander, came from fifth to claim second, and Sunrise, owned by Townsend B. Martin, captured third, 1 length behind Saidam. Kelso ended his 1963 season with nine wins in twelve starts, with two seconds and $569,762 in earnings. He was chosen the

Champion Older Horse for the third consecutive year and the 1963 Horse of the Year for the fourth consecutive year.

Kelso's 1964 season, while not as successful as his 1963 campaign, was still an excellent one. He won five races, including the Aqueduct Stakes, the Washington, D.C. International (Turf) and the Jockey Gold Cup for an incredible fifth consecutive time. The International drew the best Thoroughbreds from the United States and Europe to race the 1½-mile turf course. Kelso had competed in the race in 1961, 1962 and 1963, finishing second all three times. He would get a fourth chance on November 11 at Laurel Race Course. Competing against Kelso was Gun Bow, owned by Gedney Farms, Ireland's Biscayne II, France's Belle Sicambre, Venezuela's Primordial II, Italy's Veronese, Japan's Ryu-Forel and Russia's Anilin. Biscayne led briefly at the start of the race, but Gun Bow went on the outside and took over first. Kelso, ridden by Valenzuela, raced a close second and pulled even at the 1-mile mark. The two horses battled each other until the stretch, when Kelso finally pulled away. He crossed the finish line 4½ lengths in front of

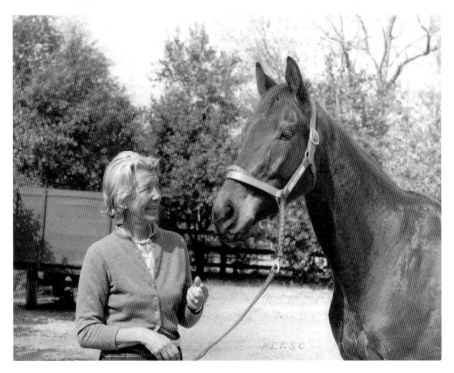

Allaire du Pont and Kelso in Aiken, South Carolina, date unknown. *Aiken Thoroughbred Racing Hall of Fame Archives.*

Gun Bow, winning in a time of 2:23 4/5. That time broke the International record of 2:24 2/5 set in 1961 and the American record of 2:24 2/5. Gun Bow finished second, and Anilin finished third, 13½ lengths behind Kelso. Gun Bow's rider, Walter Blum filed, a claim against Kelso, saying his horse felt intimidated by Kelso. Racing officials threw out the claim, and Kelso officially won his first International in four tries. He ended his 1964 season with five wins in eleven starts, with three seconds and $311,660 in earnings. Kelso was chosen the Champion Older Horse for the fourth consecutive year and the Horse of the Year for the fifth consecutive year.

Kelso would race two more years, winning the 1965 Whitney Stakes for the third time, the Stymie Handicap for the second time and the Diamond State Handicap. He would win three races in seven starts, with two thirds and $84,534 in earnings during those two years. Kelso was retired from racing after making one unsuccessful start as an eight-year-old in 1965. After his retirement, he went on to a second career as a hunter and show jumper. He made his final public appearance at the start of the 1983 Jockey Club Gold Cup at Belmont Park. He died of colic the next day, October 16, 1983. He is buried in the equine cemetery at Allaire du Pont's Woodstock Farm in Chesapeake City, Maryland.

Many of Kelso's accomplishments still stand today. He remains the only five-time Horse of the Year. He remains the only four-time Older/Handicap Horse of the Year. He was the first three-year-old named Horse of the Year that didn't win a Triple Crown race. He remains the only five-time winner of the Jockey Club Gold Cup. He is tied for the most Whitney Stakes wins, with Discovery, which won in 1934, 1935 and 1936. Kelso had the second-most wins in the Woodward Stakes, behind Forego, which won in 1974, 1975, 1976 and 1977. Kelso was ranked fourth in the "Top 100 U.S. Racehorses of the 20th Century" by *The Blood-Horse*. He was elected to the National Museum of Racing and Hall of Fame in 1967 and the Aiken Thoroughbred Racing Hall of Fame on January 23, 1977.

LAMB CHOP

Lamb Chop, a dark bay gelding, was foaled on April 9, 1960, at Claiborne Farm near Paris, Kentucky. His sire was Bold Ruler, winner of the 1957

Preakness Stakes and the 1957 Horse of the Year. Her dam was Sheepsfoot, whose sire was Count Fleet, the 1943 Triple Crown champion. She was bred by Claiborne Farm, owned by William Haggin Perry and trained by National Racing Hall of Fame member James W. Maloney (1909–1984). Lamb Chop began her three-year racing career in 1962, when she was entered in five races, winning twice and finishing second two times. She earned $7,395 that year. Her breakout year would come in 1963, when she won ten races.

The Coaching Club American Oaks (G1) was held at Aqueduct Race Track on June 22, 1963. Heliodoro Gustines got the call to ride Lamb Chop in the 1¼-mile race with ten horses in the field. Lamb Chop was the third favorite to win. The favorite was Spicy Living, who was trying to win the final leg of the Filly Triple Crown, having already won the Acorn Stakes (G1) and the Mother Goose Stakes (G1). The second favorite was Smart Deb. At the start, Smart Deb broke well from the gate and immediately went to the lead, maintaining it until the 1-mile mark. Lamb Chop, in second at the 1-mile mark, took over first place on entering the stretch. Spicy Living took over second from Smart Deb, who fell back to third. Lamb Chop won in a time of 2:02 4/5 and by 3½ lengths over Spicy Living, spoiling her bid for the Filly Triple Crown. Smart Deb ended up third, five lengths behind Lamb Chop.

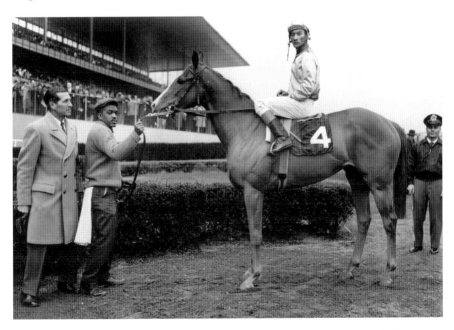

Lamb Chop after winning the 1963 Comely. *Aiken Thoroughbred Racing Hall of Fame Archives.*

The Monmouth Oaks (G1), held on July 28 at Monmouth Park, was a 1⅛-mile contest. Lamb Chop, ridden by Howard Grant, lined up again with Spicy Living and Smart Deb, along with five other fillies. The results would be the same as at the Coaching Club American Oaks, but this time the difference between the first three finishers would be closer. Main Swap, owned by Fred W. Hooper, led the race from the start until the turn for the stretch. Smart Deb, in second the entire race until the stretch, was passed by Spicy Living. Lamb Chop won in a time of 1:51 3/5, a head in front of Spicy Living and a little more than a length ahead of Smart Deb.

Lamb Chop was entered in the Spinster Stakes (G1) on August 21 at Saratoga. Only five horses entered in the 1⅛-mile race. Lamb Chop, ridden by Manuel Ycaza, was such a favorite to win that bets were not taken for this race. This was an example of how much better the filly was than her competitors. Lamb Chop was second at the ¼-mile mark and 1 length behind leader Village Beauty. Once she passed the ½-mile mark, Lamb Chop ignited and pulled away, increasing her lead to win by 11 lengths over second-place finisher Eleven Keys and 13½ lengths over third place finisher Laughing Breeze.

Lamb Chop won the Gazelle Handicap (G2), the Firenze Handicap (G2), the Santa Susana Stakes (G2), the Jersey Belle Stakes (G3) and the Comely Stakes (G3, Division 2). Her record for the year was ten wins (nine graded stakes) in sixteen starts, with four seconds, two thirds and $309,137 in winnings. She was named the 1963 Champion Three-Year-Old Filly.

Lamb Chop would race one more season, 1964, which would end in tragedy. She ran in the San Fernando Stakes on January 15 and finished second. Her next and final race was the Strub Stakes at Santa Anita. Her jockey for this 1¼-mile race was Manuel Ycaza. In this fourteen-horse field, Lamb Chop was the only female competing against the boys. She was the second favorite, with Gedney Farm's Gun Bow the favorite to win. When Lamb Chop turned into the backstretch, she stumbled and almost fell. Ycaza went over the filly's head but wasn't hurt. She was vanned off the track so veterinarians could examine her. Lamb Chop's ankle was broken from the cannon bone, and her owner made the difficult but correct decision to humanely euthanize her. Ycaza was so upset over Lamb Chop's death that he withdrew for the day from the rest of his racing assignments.

Lamb Chop was buried in the Santa Anita infield. Her career record was twenty-three starts with twelve wins (nine graded stakes), five seconds,

four thirds and career earnings of $324,032. She was elected to the Aiken Thoroughbred Racing Hall of Fame on January 23, 1977.

LATE BLOOMER

This bay mare was foaled on April 27, 1974, in Kentucky. Her sire was Stage Door Johnny, winner of the 1968 Belmont Stakes. Her dam was Dunce Cap II, whose sire was Tom Fool. Dunce Cap II was the 1985 Broodmare of the Year. Late Bloomer was bred by Greentree Stud and owned by Greentree Stable. She was trained by John M. Gaver Jr.

Late Bloomer's career began in 1976, when she ran in three Maiden Special Weight races with no wins. She had five starts in 1977, with three wins and two thirds. She earned her first win in a Maiden Special Weight race at Saratoga on August 23 and then won two allowance races. National Hall of Fame jockey Steve Cauthen was her jockey for all three of her wins. Never out of the money, she earned $25,320 in 1976.

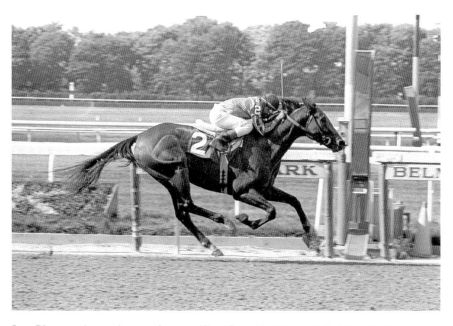

Late Bloomer, date and race unknown. *Aiken Thoroughbred Racing Hall of Fame Archives.*

Late Bloomer had an amazing 1978 season, winning six races, three of them Grade 1, in ten starts. Her first stakes win was in the Garden City Handicap on the turf at Belmont Park on May 30. She also won the New York Handicap (G3, Division 2), the Sheepshead Bay Handicap (G2) (T) and the Delaware Handicap (G1). Another win might have been added from a first-place finish in the Chou Croute Handicap at Aqueduct on May 10, but she was disqualified and placed second because of interference in the stretch run.

The Ruffian Handicap at Belmont was held on September 23, with nine horses in the field, including Mill House Stable's Sensational, the 1976 Champion Two-Year-Old Filly, and Reginald N. Webster's Pearl Necklace, who had already won the first division of the New York Handicap (G3). Jorge Velasquez was Late Bloomer's jockey for the 1⅛-mile race. Velasquez rode Late Bloomer conservatively during the first half of the race, keeping her in the middle of the field. Upon reaching the ¾-mile mark, he began moving her up the field, and at the ¾-mile mark, she was in fourth. Entering the stretch, Late Bloomer, on the inside rail, began gaining ground on Pearl Necklace, who had been in first from the gate through the stretch. The two horses battled head to head in the stretch, with Late Bloomer pulling ahead to win by 1½ lengths in a time of 1:47.

The Beldame Stakes was held on October 9 at Belmont Park. There were four horses in the field for the 1¼-mile race. Jorge Velasquez was in the irons once again for Late Bloomer. Pearl Necklace, which finished second to Late Bloomer in the Ruffian Handicap, would be her main competition in this race. Pearl Necklace moved quickly from the fourth post position to the rail to take the lead, with Late Bloomer close behind in third. Late Bloomer moved into second at the ½-mile mark, staying within striking distance of the leader. At the 1-mile mark, Late Bloomer was 4 lengths behind Pearl Necklace. Late Bloomer pulled ahead of Pearl Necklace in the stretch, leading by a head and, with less than ⅛ mile to go, continued to pull away and won by 1¼ lengths in a time of 2:02 1/5. Late Bloomer finished her 1978 season with six wins (six graded) with two seconds, two thirds and $377,458 in earnings. She won an Eclipse Award as the 1978 Champion Older Mare.

She would race one more season, earning two wins (one graded) in ten starts with two seconds and $105,662 in earnings. She won the 1979 Black Helen Handicap (G2). Her career record was twenty-four starts, eleven wins (seven graded stakes), five seconds, five thirds and $512,040 in earnings.

Late Bloomer was retired to Greentree to begin her career as a broodmare. Some of her notable offspring were Ends Well, which won the 1985 United Nations Handicap (G1), and Fred Astaire, winner of the Rutgers Handicap (G2). Late Bloomer died in 1998. She was elected to the Aiken Thoroughbred Racing Hall of Fame on March 18, 1979.

MIDSHIPMAN

Midshipman, a chestnut colt, was foaled on March 26, 2006, in Paris, Kentucky. His sire was Unbridled's Song, winner of the 1995 Breeders' Cup Juvenile and the 1996 Wood Memorial. His dam was Fleet Lady, the California Champion Three-Year-Old Filly. She was bred and owned by Stonerside Stable, owned by Robert McNair, owner of the NFL Houston Texans, and Janice McNair. The McNairs sold their highly successful

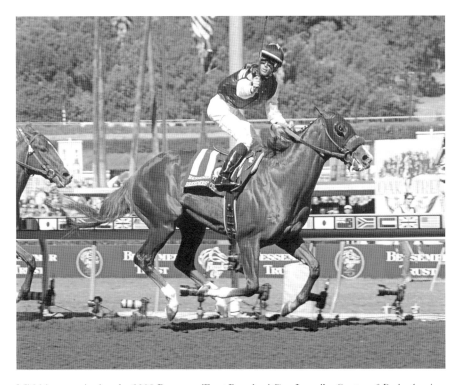

Midshipman winning the 2008 Bessemer Trust Breeders' Cup Juvenile. *Courtesy of Darley America.*

operation to the Darley racing conglomerate of Sheikh Mohammed of Dubai in 2008. Stonerside owned a training base in Aiken. Midshipman was trained by National Racing Hall of Fame member Bob Baffert.

Midshipman began his three-year race career in 2008, getting his first win in a Maiden Special Weight race at Del Mar Race Track. The race was 5½ furlongs, and he won in a time of 1:04.09. His next race was in the Del Mar Futurity (G1) on September 3. He would be competing against ten other horses in the 7-furlong race. Tyler Blaze, riding Midshipman, kept his horse off the rail in the middle of the field. Approaching the half-mile mark, Midshipman was in fifth place, 2½ lengths behind the leader, Southern Exchange. At the stretch, Midshipman was in third, 2 lengths behind the new leader, Darley's Coronet of a Baron, and ½ length behind Southern Exchange. Midshipman took over second in the stretch, and he and Coronet of a Baron battled down the stretch for the win. The Stonerside colt pulled out the victory by a head in a time of 1:23.35.

After his second-place finish in the Norfolk Stakes (G1) at Santa Anita on September 28, Midshipman was purchased by Darley. He was entered in the Bessemer Trust Breeders' Cup Juvenile (G1) at Santa Anita Racetrack on October 25. Among the horses competing in the 1¹⁄₁₆-mile race were future Kentucky Derby winner Mine that Bird. Midshipman was the second-favorite to win. Square Eddie, which won the Lane's End Breeders' Futurity, was a slight favorite to win. Street Hero, winner of the Norfolk Stakes (G1), was also competing in the race.

Square Eddie, Midshipman and Street Hero were first, second and third, respectively, at the start of the race to the ¼-mile mark. These three horses continued to battle each other throughout the race. Midshipman took control of the race at the ½-mile mark with a ½-length lead over Square Eddie. Street Hero moved past Square Eddie at the ¾-mile mark and increased his lead from a head to a length. Entering the stretch, Midshipman was still in first, with Street Hero and Square Eddie close behind. Square Eddie rallied to pass Street Hero and took over second, but he could not catch Midshipman, who crossed the wire first. Midshipman, ridden by Garrett Gomez, won by 1¼ lengths in a time of 1:40.95. Square Eddie captured second over Street Hero by 1¼ lengths. Midshipman finished his freshman season with three wins (two graded stakes) in four starts, one second and $1,380,200 in earnings. Midshipman won an Eclipse Award as the 2008 Champion Two-Year-Old Colt.

Midshipman would race only twice in 2009, finishing third in the Breeders' Cup Dirt Mile (G1) and winning an allowance race. He finished the year with $128,400 in earnings. He was sent to Dubai, United Arab Emirates, in 2010, where he won a seven-furlong conditions race and earned a fourth-place finish in the Invasor Shadwell Farm Al Maktoum Challenge-Round 1 (G3). Midshipman was retired after that race and finished his career with five wins in eight starts, with one second, two thirds and $1,584,600 in earnings.

He returned to the United States to stand at stud beginning in 2011 at Darley in Kentucky. His most notable offspring is Lady Shipman, winner of Royal North Stakes (G3); her career statistics include nineteen starts with thirteen wins, two seconds, two thirds and $896,042 in earnings. Midshipman was elected to the Aiken Thoroughbred Racing Hall of Fame on March 15, 2008.

Neji

Neji, a chestnut gelding, was foaled in 1950 in England. His sire was Hunters Moon IV, who was foaled in France. Hunters Moon IV's great-grandsire was Man o' War. Neji's dam was Accra, whose grandsire was Man o' War. Neji was bred by Marion duPont Scott and owned by Lillian Bostwick Phipps (1906–1987). Her brother George H. "Pete" Bostwick (1909–1982) trained her horses. He was inducted into the National Racing Hall of Fame in 1968 as a jockey.

Neji's career began in 1953, but he didn't win his first race until May 15, 1954. He won the Belmont National Maiden Hurdle, a 1¾-mile race over hurdles, in a time of 3:15. Additionally, in 1954, he won the Brook Steeplechase Handicap, the Monmouth National Maiden Hurdle and the Saratoga National Maiden Hurdle. Neji would have five wins in twenty starts with five seconds, three thirds and $40,875 in earnings for 1954.

The gelding had a standout year in 1955, winning five races, including the International Steeplechase, Brook Steeplechase Handicap, the Grand National Steeplechase Handicap and the Temple Gwathmey Steeplechase Handicap.

The Temple Gwathmey race was run on October 21 at Belmont. This was a 2½-mile race with sixteen hurdles and eleven entries. One of Neji's

competitors in the race was Hyvania, owned and trained by Pete Bostwick. Neji was being ridden by Frank D. "Dooley" Adams. Templier, owned by Mrs. Michael G. Walsh, led for most of the race until the ninth hurdle, when he fell and unseated his rider. His Boots, owned by Brookmeade Stable, took over first; Rythminhim, also owned by Walsh, was in second. Both horses maintained their positions at the twelfth hurdle. Hyvania was in third, and Neji was in fifth at the twelfth hurdle. Rythminhim had taken the lead from His Boots, who dropped to third after the sixteenth hurdle, and Neji moved up to second. It looked like Rythminhim would win, but he came up lame in the stretch. Neji was able to pass him for the win in a time of 5:44 3/5. Rythminhim was found to have a broken pelvis after the race. Remarkably, he eventually recovered from his injury; he won the 1958 Harbor Hill Steeplechase Handicap. Neji finished his 1955 year with five wins in eight starts with one second, two thirds and $91,405 in earnings. He was named the 1955 Champion Steeplechase Horse.

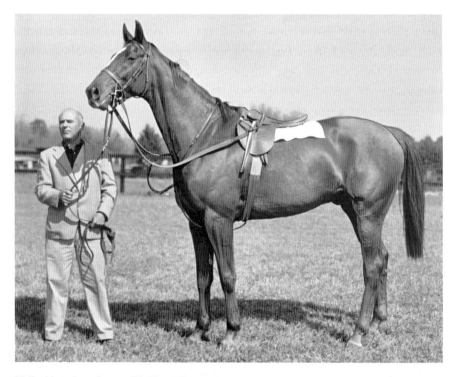

Neji with trainer George W. "Pete" Bostwick, date unknown. *Aiken Thoroughbred Racing Hall of Fame Archives.*

Neji raced six times in 1956, winning twice with three seconds, one third and $26,560 in earnings. He won the Indian River Steeplechase and Meadow Brook Steeplechase Handicap. This was the last year that Pete Bostwick trained Neji.

The American Grand National Steeplechase Handicap is a race that every steeplechase owner would love to win. Lillian Phipps had already won the race in 1951 with Oedipus and with Neji in 1955 and hoped to win a third with Neji in 1957. Neji's new trainer was Daniel Michael "Mikey" Smithwick, who would be inducted into the National Racing Hall of Fame as a trainer in 1971. The American Grand National was held on October 8 at Belmont. There were only five entries in the 3⅛-mile race, which had sixteen hurdles. His Boots, who finished third in Neji's win in the 1955 Temple Gwathmey Steeplechase Handicap, would compete in the race. Neji was ridden by Alfred "Paddy" Smithwick, who was inducted into the National Racing Hall of Fame in 1973 as a jockey. Neji raced in fourth for the first eight hurdles but moved up to third at the twelfth hurdle. He was 3 lengths behind Independence, who had taken over first place at the fifteenth hurdle when early leader Caste lost his rider. Approaching the last hurdle, Neji took the lead from Independence; once in the stretch, the gelding increased his lead from ½-length to 6 lengths and earned the victory in a time of 6:15 1/5, setting a new course record. Neji would also win the Brook Steeplechase Handicap and the Temple Gwathmey Steeplechase Handicap. He finished the 1957 season with three wins in four starts and $74,900 in earnings. He was named the 1957 Champion Steeplechase Horse.

Neji won only two races in 1958. The first, the Prelude Purse, was a 1¾ mile contest at Monmouth on July 19. Neji won in a time 3:15.10, which set a new course record. Neji also broke the world earnings record for steeplechase horses with the win. The second victory came in the Grand National Steeplechase Handicap, a race Neji had won in 1955 and 1957. The 3⅛-mile race had nine contestants in the field, including Rythminhim, who survive a nearly career-ending injury in the 1955 Temple Gwathmey Steeplechase Handicap. Neji was ridden by Alfred "Paddy" Smithwick, his regular rider. Dromond, owned by Montpelier Stable, led from the fourth to the twelfth hurdle, but he fell to sixth after the sixteenth hurdle. Neji was steady in fifth place until the sixteenth hurdle. After he cleared it cleanly, he was in the lead by a head over Darubini, owned by June H. McKnight. Neji increased his lead in the stretch by 2½ lengths over Rythminhim, who

had passed Darubini in the stretch to capture second. Neji's winning time was 6:06, which broke his own track record. He finished his 1958 season with two wins in five starts with one second, two thirds and $33,944. He was named the 1958 Champion Steeplechase Horse.

Neji was sent to Ireland on November 28 to train for the Cheltenham Gold Cup in England on March 5, 1959. He injured himself in the Leopardstown Chase on February 21 in Dublin, Ireland. He was shipped back to the United States on March 16 and didn't race the rest of the year. Neji raced in 1960 but did not achieve the success of previous years. He made three starts with one second and $3,010 earnings.

He was retired in 1960, ending his career with seventeen wins in forty-six starts with eleven seconds, eight thirds and $270,694 in earnings. He was inducted into the National Racing Hall of Fame in 1966. Neji was elected to the Aiken Thoroughbred Racing Hall of Fame on January 23, 1977.

OEDIPUS

This brown gelding was foaled in 1946 in the United States. His sire was Blue Larkspur, who won the 1929 Belmont Stakes and was the 1929 Horse of the Year, 1929 Champion Three-Year-Old Colt and 1930 Champion Older Male Horse. Blue Larkspur was inducted into the National Racing Hall of Fame in 1957. Oedipus's dam was Be Like Mom, whose dam was Black Helen, the 1935 Champion Three-Year-Old Filly and inducted into the National Racing Hall of Fame in 1991. Oedipus was bred by Edward R. Bradley's Idle Hour Stock Farm and owned by Lillian Bostwick Phipps and trained by George H. Bostwick.

Oedipus's first two years of racing (1948 and 1949) didn't give a hint of the type of steeplechase horse he would become. He was entered in six races, with no wins, in 1948. He was entered in six races in 1949, winning one race with three seconds, one third and $3,645 in earnings. The first race he won was a Maiden Special Weight Hurdles on August 30, 1949, at Aqueduct.

In 1950, Oedipus won five times, including the Aqueduct Spring Maiden Steeplechase, the Shillelah Steeplechase, the Broad Hollow Steeplechase Handicap and the Brook Steeplechase Handicap. The Broad Hollow was held on September 22 at Belmont. This was a two-mile race with twelve

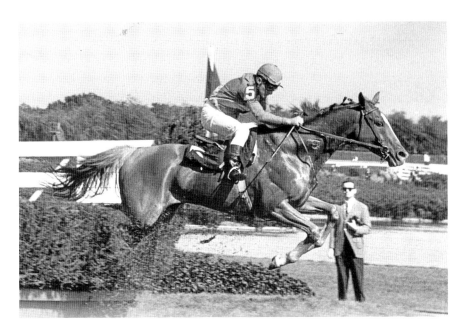

Oedipus, date and race unknown. *Aiken Thoroughbred Racing Hall of Fame Archives*.

hurdles. There were ten entries, including Elkridge, the 1942 and 1946 Steeplechase Horse of the Year. Oedipus, ridden by Charles H. Williams, started in fourth, but by the third hurdle he had moved up to second, leading the field by two lengths. He took the lead after clearing the twelfth hurdle. Elkridge was in sixth for most of the race but gradually moved up and, after taking the twelfth hurdle, was in second place, two lengths behind Oedipus. Elkridge was able to gain some ground in the stretch, but it wasn't enough to catch the Phipps gelding. Oedipus won by 1¼ lengths over Elkridge in a time of 3:48 2/5. Oedipus finished the 1950 season with five wins in fifteen starts with three seconds, two thirds and $40,450 in earnings. He was named the 1950 Champion Steeplechase Horse.

The 1951 season would be the best of Oedipus's career. He would win five of the most important steeplechase contests; the Brook Steeplechase Handicap for the second time, the Broad Hollow Steeplechase Handicap for the second time, the Beverwyck Steeplechase Handicap, the Corinthian Steeplechase Handicap and the Grand National Steeplechase Handicap. The Grand National was held on October 12 at Belmont. It was a three-mile race over nineteen hurdles with ten competitors. Oedipus was ridden by Albert Foot. His main competition came from L.W. Jennings's Navy Gun,

ridden by Frank D. Adams, and from Mrs. Raymond G. Woolfe's Banner Waves. Navy Gun started off in first through the fifth hurdle and lost his lead to Banner Waves, with Oedipus ahead of him in second. Banner Waves still had the lead over Oedipus and Navy Gun after clearing the tenth hurdle. The gap between the horses began to close at the fifteenth hurdle—1½ lengths separated Banner Waves, Oedipus and Navy Gun. Heading to the nineteenth and last hurdle, Oedipus took the lead, with Navy Gun in second and Banner Waves falling back to third. Racing down the stretch, Oedipus won by 1½ lengths over Navy Gun in a time of 5:50 1/5. Banner Waves finished in third, 2½ lengths behind Navy Gun. This was Oedipus's last race of the 1951 season. He finished with five wins in eleven starts with two seconds, two thirds and $54,875 in earnings. He was named the 1951 Champion Steeplechase Horse.

Oedipus won the Broad Hollow Steeplechase Handicap in 1952, for the third time, and the Shillelah Steeplechase Handicap. The Broad Hollow Steeplechase was held on September 18 at Belmont. There were eight entries in the two-mile race, with twelve hurdles. Oedipus, ridden by Albert Foot, was in second place at the start of the race and had fallen to third after clearing the third hurdle. He was two lengths behind leader The Creek, owned by F. Ambrose Clark, and one length behind second-place Jam, owned by James F. McHugh. After clearing the ninth hurdle, Oedipus moved up to second, ½ length behind The Creek. Oedipus toke over the lead by 1½ lengths after clearing the twelfth hurdle, with Jam in close pursuit. The two horses battled bravely down the stretch, with Oedipus winning by a head in a time of 3:39 1/5, setting a new course record. The Creek finished third, more than 20 lengths behind Jam. Oedipus finished the 1952 season with two wins in nine starts, with two seconds, two thirds and $21,810 in earnings. He was named the 1952 Champion Steeplechase Horse.

Oedipus would race for two more years (1953 and 1954), during which he had one win in ten starts, with two seconds, two thirds and $11,625 in earnings. He won the 1953 Charles L. Appleton Memorial Steeplechase. He was retired in 1954 with fourteen wins in fifty-eight starts, with twelve seconds, nine thirds and $132,405 in earnings. Oedipus died in 1978, the same year he was inducted into the National Racing Hall of Fame. He was elected to the Aiken Thoroughbred Racing Hall of Fame on January 23, 1977.

OPEN FIRE

Open Fire, a roan mare, was foaled on May 22, 1961, in Virginia. Her sire was Cochise, who won the 1951 Arlington Handicap. Her dam was Lucy Lufton, whose sire, Nimbus, was the 1949 Champion Three-Year-Old in England. She was bred by Renappi Corporation and owned by Brandywine Stable, both owned by Donald P. Ross. Open Fire was trained by Virgil W. "Buddy" Raines, who had a training base at the Aiken Training Track.

Open Fire's 1963–65 record included six wins in twenty starts with five seconds, five thirds and $49,725 in earnings. Her best racing season would be her last one, 1966. In that year, she won four graded stakes, including the New Castle Stakes on July 16, winning the 1⅙-mile race in a time of 1:42.60.

The Delaware Handicap was held on July 30 at Delaware Park. This was a 1¼ mile race with thirteen horses in the field. Harborvale Stable's Summer Scandal was the favorite. Open Fire ran well in the early part of the

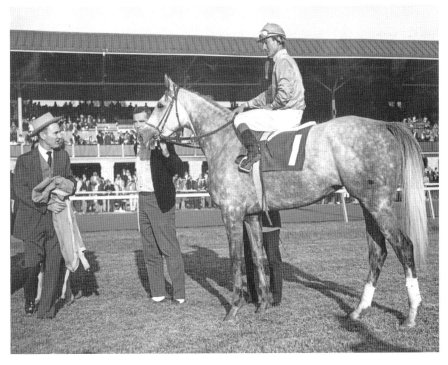

Open Fire after winning the 1966 Spinster Stakes. *Aiken Thoroughbred Racing Hall of Fame Archives.*

race, staying in fourth place under a tight hand ride by jockey Frank Lovato. Reaching the ½-mile mark, she was in second place, ½ length behind the leader, Summer Scandal. She pulled into the lead at the ¾-mile mark, leading Wheatley Stable's Disciple, which had taken over second place from Summer Scandal. At the top of the stretch, Open Fire was leading by 4½ lengths over Disciple and by 6½ lengths over P. Jacobs's Treachery. Summer Scandal had fallen to fourth, 7 lengths back. Open Fire swung wide on the stretch turn, losing a little ground, but, under the steady hand of Lovato, increased her lead down the stretch. She won by 5 lengths in a time of 2:00 2/5, equaling the track record. Treachery was able to pass Disciple to take second by 2 lengths.

The Diana Handicap, for fillies and mares, was held on August 22 at Saratoga. There were eight horses in the field for the 1⅛-mile race on a sloppy track. Disciple, one of Open Fire's opponents from the Delaware Handicap, was entered in the race. Open Fire was again ridden by Frank Lovato and was the favorite in the race. When the gates opened, the Brandywine mare was in second place, ½ length behind the leader, Reluctant Pearl, owned by Christiana Stable. Open Fire took the lead at the ½-mile mark and never relinquished it. She was in the lead by a head and increased her lead with every stride. Reluctant Pearl maintained her second-place position the rest of the race but could not keep up with the fleet Open Fire to challenge for the lead. At the top of the stretch, Open Fire was leading by 4 lengths and, despite the muddy track, opened her lead to 10 lengths by the time she crossed the finish line. She broke the track record, winning in a time of 1:48 4/5. Disciple, not able to repeat her third-place performance from the Delaware Handicap, finished last.

The Spinster Stakes was held on October 27 at Keeneland. It was a 1⅛-mile contest, and Braulio Baeza was in the saddle for Open Fire. Her biggest competitor in the race was Summer Scandal, who finished fourth to Open Fire's first at the Delaware Handicap on July 30. Open Fire took the lead in the final sixteenth of the race to win by 2½ lengths in a time of 1:50 2/5. She finished the 1966 season with seven wins (four graded stakes) in ten starts with one second and $177,604 in earnings. She was named the 1966 Champion Handicap Mare. She was retired at the end of 1966. Her four-year career record included thirteen wins (four graded stakes) in thirty starts, with six seconds, five thirds and $227,329 in earnings. Open Fire became a broodmare after her retirement and

produced seven foals, none of which were successful in racing. Open Fire died in 1980. She was elected to the Aiken Thoroughbred Racing Hall of Fame on January 23, 1977.

PLEASANT COLONY

Pleasant Colony, a dark bay horse, was foaled on May 4, 1978, in Gainesville, Virginia. His sire was His Majesty, named the Leading Sire in North America in 1982. His dam was Sun Colony, who won the Gallorette Handicap in 1972. He was bred and owned by Buckland Farm, owned by Thomas Mellon Evans (1910–97). Buckland maintained a training base in Aiken. Pleasant Colony was trained by John P. Campo (1938–2005).

Pleasant Colony's two-year career began in 1980. He won his first race, a Maiden Special Weight contest, on September 22 at Meadowlands Racetrack in New Jersey. He also won the Remsen Stakes (G2). His freshman year ended with two wins (one graded stakes) in five races, with one second and $87,968 in earnings.

His 1981 season ensured his place in racing history due to his performance in the Triple Crown. The 107th running of the Kentucky Derby (G1) was held on May 3 at Churchill Downs with an incredible twenty-one horses in the field. The favorite to win was Proud Appeal, which had won four graded stakes, including the Bluegrass Stakes (G1), prior to the Kentucky Derby. But Proud Appeal would finish a disappointing eighteenth in the Derby.

Pleasant Colony started from post seven and was ridden by Jorge Velasquez. He would keep Pleasant Colony under control but continued to move closer to the pace of the leaders. Pleasant Colony was in seventeenth place at the ¼-mile mark, then fifteenth at the ¾-mile mark. By the mile mark, Velasquez had guided his horse to eighth place. Top Avenger held the lead until the mile mark, when Bold Ego overtook him. Pleasant Colony was driven to the outside of the field; arriving at the top of the stretch, he quickly moved from eighth to first place, passing Bold Ego. Partez moved into second place at the mile mark but couldn't hold it as Woodchopper, closing fast in the stretch, passed him with his eye on Pleasant Colony. Woodchopper couldn't catch the Buckland colt, who was able to hold on for a ¾-length win in a time of 2:02, which was 2 ⅗ seconds off the Churchill

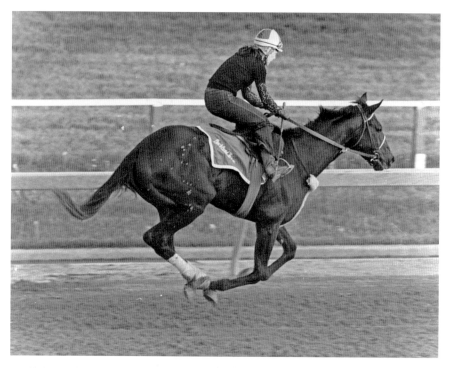

Pleasant Colony training at the Aiken Training Track, 1981. *Aiken Thoroughbred Racing Hall of Fame Archives.*

Downs track record set by Secretariat. Woodchopper finished in second, and Partez took third.

The 106th Preakness Stakes (G1) was held on May 16 at Pimlico with thirteen horses in the field, including the top three finishers in the Kentucky Derby: Pleasant Colony, Woodchopper and Partez. Pleasant Colony, the favorite to win, was once again ridden by Jorge Velasquez. Bold Ego, who also ran in the Kentucky Derby, took the lead from the opening of the gates to the top of the stretch. Pleasant Colony started in third at the start but dropped back and stayed between sixth and ninth for most of the race until reaching the top of the stretch. Velasquez strongly urged the Buckland colt to speed it up when entering the stretch, and Pleasant Colony answered by quickly moving into second, ½ length behind Bold Ego. The two horses battled for the win from the ¼-mile mark to the ⅛-mile mark, with Pleasant Colony gutting out a one length victory over Bold Ego. Pleasant Colony tied the record for the fastest Preakness final sixteenth, to win the 1⅙-mile race in a time of 1:54 3/5. Paristo, a longshot in the race, finished third. The

win gave Pleasant Colony's owner, trainer and jockey their first Preakness victories. After his win, Pleasant Colony's trainer, John P. Campo, guaranteed that his horse would win the Belmont Stakes and become the first Triple Crown winner since Affirmed in 1978. Sometimes, overconfidence can be someone's downfall, as Campo would learn in June.

The Belmont Stakes was held on June 6, with Pleasant Colony the heavy favorite to become the twelfth Triple Crown winner. There were eleven horses in the field, including Woodchopper, which had finished second in the Kentucky Derby, and Bold Ego, which had finished second in the Preakness Stakes. Jorge Velasquez, who rode the Buckland colt in the Kentucky Derby and the Preakness Stakes, got the call to ride him in the Preakness. Pleasant Colony did not break well from the gate, and many felt that this was due to being startled by a photographer who was at the gate. He balked at going into his gate stall, and that delayed the race while the assistant starters had to coax him in. He started the race as last in the field and held that position through the $\frac{1}{2}$-mile mark. Velasquez rode him into contention by the $1\frac{1}{4}$ mark, getting him into third place. Entering the top of the stretch, he was $4\frac{1}{2}$ lengths behind the leader, Summing, and $\frac{1}{2}$ length behind Highland Blade, in second. Summing and Highland Blade pulled away in the stretch from Pleasant Colony. Summing won by a neck over Highland Blade. Pleasant Colony was $12\frac{1}{2}$ lengths behind the winner. Campo took the loss in stride, saying, "You can't win them all."

Pleasant Colony would also win the Woodward Stakes (G1) and the Wood Memorial Stakes (G1). He finished up his 1981 season with four wins (four graded stakes) in nine starts with two seconds, one third and $877,415 in earnings. Pleasant Colony received an Eclipse Award as the 1981 Champion Three-Year-Old Colt. He was retired in 1982 with a career of six wins (five graded stakes) in fourteen starts with three seconds, one third and $965,383 in earnings.

Pleasant Colony had much success as a sire and stood at stud at Buckland Farm in Virginia from 1982 to 1998 and later at Lane's End in Kentucky (1998–2000). He sired 166 offspring and was named the fourth-leading sire in 1991 and the second-leading sire in 1992. His notable offspring were Pleasant Stage, winner of the 1991 Breeders' Cup Juvenile Fillies (G1) and the 1991 Eclipse Award Champion Two-Year-Old Filly; Pleasant Tap, winner of the 1992 Jockey Gold Cup (G1), the 1992 Suburban Handicap (G1) and the 1992 Eclipse Award Champion Handicap Horse; and Pleasantly Perfect,

winner of the 2003 Breeders' Cup Classic and 2004 Dubai World Cup. Pleasant Colony was pensioned at Lane's End in 2000 and then relocated to the Kentucky Horse Park. He was sent to Blue Ridge Farm in Virginia so he could enjoy his retirement in a quieter location. Pleasant Colony died in his sleep on December 31, 2002, at age twenty-four and was buried at his birthplace, Buckland Farm. He was elected to the Aiken Thoroughbred Racing Hall of Fame on March 14, 1982.

PLEASANT STAGE

Pleasant Stage, a bay mare, was foaled on March 14, 1989, in Gainesville, Virginia. Her sire was Pleasant Colony, winner of the 1981 Kentucky Derby and 1981 Belmont Stakes. Her dam was Meteor Stage, whose sire was Stage Door Johnny, winner of the 1968 Belmont Stakes. Pleasant Stage was bred by Mrs. Thomas Mellon Evans (1923–2013) and owned by Buckland Farm. She was trained by Christopher Speckert.

Pleasant Stage's two-year racing career began in 1991. She ran four races that year, winning two, both graded stakes. She seemed to like running from the back field for most of a race and making her charge during the stretch. Her first win came in the Oak Leaf Stakes (G2), on October 14 at Santa Anita. This was a $1^1/_{16}$-mile contest, and the race had five competitors. Soviet Sojourn, owned by Hal J. and Patti Earnhardt, had already won two graded stakes, the Junior Miss Stakes (G3) and the Sorrento Stakes (G3) and was the favorite to win the race. Pleasant Stage was ridden by Eddie Delahoussaye, who would be inducted into the National Racing Hall of Fame in 1993. Pleasant Stage was running last for the first $^1/_2$ mile of the race, and Delahoussaye patiently moved her up to third at the $^1/_2$-mile mark, where she was still about two lengths behind the leader. At the top of the stretch, she began to make her charge and moved into third place, behind Soviet Sojourn and La Spia, who were focused on each other. Pleasant Colony was gaining ground quickly; at the sixteenth pole, she blew past them and won by two lengths in a time of 1:43.53.

Pleasant Stage's next race was the Breeders' Cup Juvenile Fillies (G1) at Churchill Downs on November 2. This was a $1^1/_{16}$-mile race with fourteen fillies competing, including Soviet Sojourn and La Spia. Pleasant Stage,

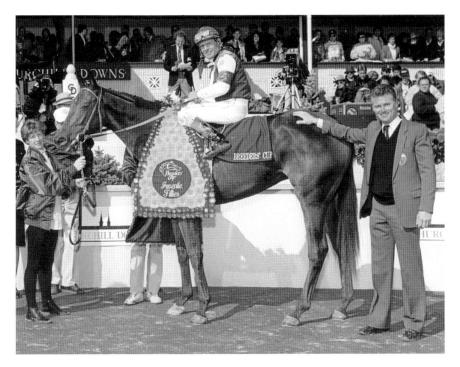

Pleasant Stage after winning the 1991 Breeders' Cup Juvenile Fillies Championship. *Aiken Thoroughbred Racing Hall of Fame Archives.*

ridden once again by Eddie Delahoussaye, started in her normal rear position, running in twelfth at the ¼-mile mark. She slowly moved up to tenth place by the ½-mile mark and dropped back to eleventh at the ¾-mile mark. Delahoussaye guided Pleasant Stage through the field in the stretch into fourth place. La Spia was in first; with only one hundred yards to go, it looked like the race was all but over. But Pleasant Stage came fast on the inside, caught up with La Spia at the wire and won by a head. She won in a time of 1:39.47. Pleasant Stage ended her freshman year with two wins in four starts, one second, one third and $687,240 in earnings. She won an Eclipse Award as the 1991 Champion Two-Year-Old Filly.

Pleasant Stage would not repeat the success of her 1991 season. She would start in six races with two seconds, one third and $157,032 in earnings. Her two second-place finishes came in the Kentucky Oaks (G1) and the Acorn Stakes (G1). Her third-place finish came in the Coaching Club American Oaks (G1). She died of a heart attack during an allergic reaction to a routine vitamin shot at Del Mar on August 28. She was to have run in the Del Mar

Oaks on August 30 and was the favorite in the race. She was elected to the Aiken Thoroughbred Racing Hall of Fame on March 15, 1992.

PLEASANT TAP

This bay mare was foaled on May 8, 1987, in Gainesville, Virginia. His sire was Pleasant Colony, who won the 1981 Kentucky Derby and Belmont Stakes. His dam was Never Knock, whose sire was Stage Door Johnny, winner of the 1968 Belmont Stakes. He was bred by Thomas Mellon Evans (1923–2013), owned by Buckland Farm and trained by Christopher Speckert.

Pleasant Tap's four-year career began in 1989, when he started in five races with one win, in the Sunny Slope Stakes. He finished second in the Hoist the Flag Stakes (G2) and earned $80,725 by the end of the year. His sophomore year would see him win three races out of nine starts, with two seconds and one third (in the Kentucky Derby). His win in the Malibu Stakes (G2) raised his yearly earnings to $210,530. Pleasant Tap's 1991 season had only one win in eight starts, but with his second-place finish in the Breeders' Cup Sprint (G1) and third-place finish in the Santa Anita Handicap (G1), he finished the year with $470,000 in earnings.

The year 1992 would be an incredible one for the Buckland colt, with four wins in ten starts. All four victories came in graded stakes contests. He won the seven-furlong Commonwealth Breeders' Cup Stakes (G3) in a time of 1:22.40 and the seven-furlong Churchill Downs Handicap (G3) in 1:22.32. He finished second in the Metropolitan Handicap (G1), the Woodward Stakes (G1) and the Nassau County Handicap (G2).

The Suburban Handicap (G1) was held on July 18 at Belmont Park. This was a 1¼-mile contest with seven horses, including Strike the Gold, winner of the 1991 Kentucky Derby (G1) and the Bluegrass Stakes (G2). Eddie Delahoussaye got the call to ride Pleasant Colony in this race. Strike the Gold, the favorite to win, had just beaten Pleasant Tap in the Nassau County Handicap (G2). Pleasant Tap was fifth at the ¼-mile mark of the race but moved up to third at the 1-mile mark. Strike the Gold was in seventh place at the ¾-mile mark and was quickly closing the gap with Pleasant Tap. When both horses entered the stretch, Pleasant Tap was still in third, but only 1 length ahead of Strike the Gold, who had moved

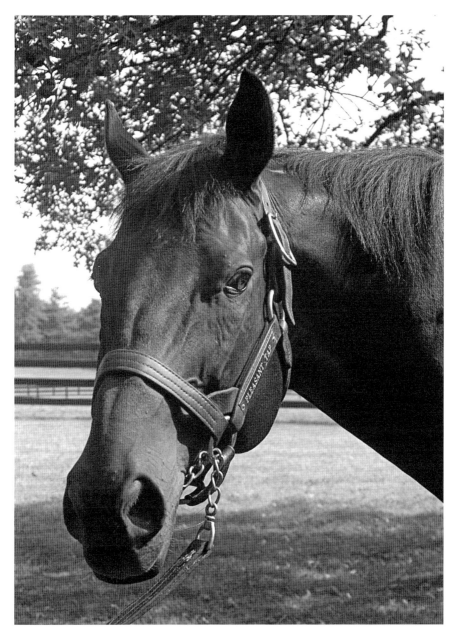

Pleasant Tap at Lane's End Farm in Versailles, Kentucky, in 2005. *Author's Collection.*

up to fourth. The two horses battled each other down the stretch, passing Defensive Play, owned by Juddmonte Farms. Pleasant Tap was finally able to put some distance between himself and Strike the Gold, winning by 1½ lengths in a time of 2:00.33.

The Jockey Club Gold Cup Stakes (G1) was held on October 10 at Belmont Park. This was a 1¼-mile contest with seven horses in the field, including Strike the Gold and A.P. Indy, the winner of the 1992 Belmont Stakes (G1) and the Santa Anita Derby (G1). Gary Stevens, who would be inducted into the National Racing Hall of Fame in 1998, rode Pleasant Tap in this race. Pleasant Tap was the favorite to win, and Strike the Gold and Sultry Song were co-second choices.

Pleasant Tap ran in fifth for the first mile of the race, behind Devil His Due in first, Missionary Ridge in second, Thunder Rumble in third and Sultry Song in fourth. He finally caught up with the leaders at the mile mark and then exploded past them to take over first. Turning into the stretch, Pleasant Tap was leading by 2 lengths over Strike the Gold, who had moved up from sixth to second place. A.P. Indy, who was last for most of the race, gamely fought his way up to third, 6¾ lengths behind Pleasant Tap. Neither horse had enough left to catch Pleasant Tap, who won by 4½ lengths in a time of 1:58 4/5. The win qualified him to run in the Breeders' Cup Classic.

Pleasant Tap would end his 1992 season with a second-place finish behind A.P. Indy in the Breeders' Cup Classic (G1) on October 31. Pleasant Tap's season totals were four wins (four graded stakes) in ten starts, five seconds and $1,959,914 in earnings. He won an Eclipse Award as the 1992 Champion Older Horse.

Pleasant Tap was retired in 1993, and his career ended with nine wins (six graded stakes) in thirty-two starts with nine seconds, five thirds and $2,721,169 in earnings. He entered stud in 1993 at Buckland Farm near Lexington, Kentucky, and stood there until he was relocated to Lane's End in 1997. He sired Premium Tap, winner of the 2006 Woodward Stakes (G1) and Tap to Music, which won the 1998 Gazelle Handicap (G1). His most famous offspring was Tiago, winner of the 2007 Santa Anita Derby (G1), the 2007 Goodwood Stakes (G1), the 2007 Swaps Breeders' Cup Stakes (G2) and the 2008 Oaklawn Handicap (G2).

Pleasant Tap was euthanized on October 8, 2010, because of laminitis at William S. Farish's Lane's End Farm near Versailles, Kentucky. He was

twenty-three years old. He was elected to the Aiken Thoroughbred Racing Hall of Fame on March 14, 1993.

POLITELY

This chestnut mare was foaled on April 21, 1963, in Maryland. Her sire was Amerigo, which foaled in England and won the 1937 Coventry Stakes. Her dam was Morn Again, whose great damsire was Man o' War. Politely was bred and owned by Allaire du Pont's Bohemia Stable. Politely was trained by George M. Baker. Bohemia Stable had a training base at the Aiken Training Track.

Politely began her racing career in 1965, when she ran in nine races with one first, three seconds and $11,042 in earnings. Her wins in 1966 and 1967 came in the 1966 Princeton Handicap, the 1967 Matchmaker Stakes, the 1967 Firenze Handicap and the 1967 Molly Pitcher Handicap. She had six wins in twelve starts with four seconds, four thirds and $224,457 in earnings in those two years.

Politely's 1968 season would be her best and final season. She won eight races, including the Molly Pitcher Handicap for the second time, the Firenze Handicap for the second time, the Matchmaker Stakes for the second time, the Sheepshead Head Bay Handicap (Division 2), the Ladies Handicap, the Vineland Handicap and the Delaware Handicap.

The 1⅛-mile Matchmaker Stakes was run on October 6 at the Atlantic City Racetrack. The name of the race gives a clue as to the third- and fourth-place awards given, the first two being prize money and a trophy. The third prize was that the owners of the top three finishers received an opportunity to have one of their mares mate with one of three sires, Lydia Tesio and Marquese della Rocchetta's Ribot, Harbor View Farm's Hail to Reason and Tartan Stable's Intentionally. The fourth prize was that the owners of the three top finishers got to keep the offspring to train, race or sell. There were eleven competitors in this race, including William Haggin Perry's Princessnesian, Rokeby's Stable's Green Glade and Amerigo Lady. Politely's rider was Angel Cordero Jr. At the beginning of the race, Cordero had her under light restraint and kept her in fifth and sixth place in the first ½ mile. She moved into fourth place after the ½-mile mark and into third

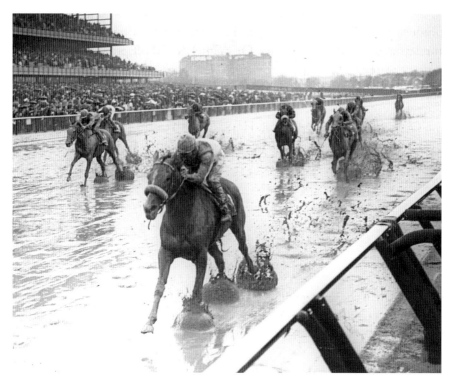

Politely winning the 1968 Firenze Handicap. *Aiken Thoroughbred Racing Hall of Fame Archives.*

place at the ³/₄-mile mark. When Cordero drove Politely into the stretch, he let her have her lead, and she won by 4¹/₂ lengths over Green Glade, which finished second, and Amerigo Lady, which finished third. She equaled her own stakes and track record, winning in a time of 1:55 1/5. Mrs. du Pont chose the services of European stallion Ribot for Bohemia Stable, while Paul Mellon earned the services of Hail to Reason and Intentionally for Rokeby Stable.

Politely's last race came in the Firenze Handicap on November 28 at Aqueduct. She ended her 1968 season with a victory there. She was retired after the race and ended the season with eight wins in fourteen starts, with two seconds, one third and $317,473 in earnings. She finished her career with twenty-one wins in forty-nine starts, nine seconds, five thirds and $552,972 in earnings.

Politely was sent to du Pont's Woodstock Farm in Maryland, where Bohemia Stables was located, to begin her career as a broodmare. She would

produce ten offspring, one of which, Salutely, was a top sire of distance runners and steeplechase horses. Of Salutely's 170 offspring who raced, 81 percent were winners and averaged thirty-two races per horse, with thirty-three of these running over fifty races. Salutely is also the top producer of timber horses in the country. The most famous of these runners is Saluter, the *Chronicle of the Horse*'s Overall Horse of the Year in 1999.

Politely was the first horse to be named Maryland-bred Horse of the Year (1967–68). She was elected to the Aiken Thoroughbred Racing Hall of Fame on January 23, 1977.

QUICK PITCH

Quick Pitch, a chestnut gelding, was foaled on March 17, 1960, in Kentucky. His sire was Charlevoix, and his dam was Ghizeh. He was bred and owned by Fortune Peter Ryan (1911–1983). Quick Pitch was trained by Ryan's brother E. Barry Ryan (1920–1993), who had a training base at Aiken.

Quick Pitch began his career in 1962. Through the 1966 season, he had started in fifty-seven races with seventeen wins, twelve seconds, five thirds and $181,866 in earnings. His important wins during that time frame came in the 1963 Brighton Beach Handicap, 1965 Bernard Baruch Handicap, 1965 Niagara Handicap (Canada), 1965 Jockey Club Cup Handicap (Canada) and the 1966 Fair Play Stakes (Canada). Quick Pitch's best year was 1967.

The Holly Tree Hurdle Handicap was run on July 27 at Delaware Park. Ronald Armstrong was in the irons for the $1\frac{3}{4}$-mile race over nine hurdles. Quick Pitch had no trouble with any of the hurdles and coasted to a win in a time of 3:31, six lengths ahead of second-place My Chap and seventeen lengths ahead of third-place finisher Calanthe. Other important races he won included the Bushwick Hurdle Handicap and the Midsummer Hurdle Handicap.

The Rouge Dragon Hurdle Handicap (Turf) was run on September 14 at Aqueduct. There were six horses in the field for the $2\frac{1}{2}$-mile race. Quick Pitch was ridden by Jim Mahoney, who guided the horse in the lead from the start of the race. He increased his lead with every fence he cleared; when arriving at the fourteenth hurdle, he had a twelve-length lead over second-place Gay Sparkle. Quick Pitch had cleared all the

previous hurdles with no problems, but at this last hurdle he acted like he wanted to go through the hurdle instead of over it. Mahoney was able to refocus the gelding, get him over the hurdle and on to win by fourteen lengths in a time of 4:30 2/5, a new course record. Gay Sparkle, owned by B.C. Brittingham, finished second, and Brandon Hill, owned by Augustin Stable, finished third. Quick Pitch ended the 1967 season with six wins in seven starts, one third and $45,351. He was named the 1967 Champion Steeplechase Horse. He would race one more season, 1968, with just two starts, one third and $2,000 in earnings.

Quick Pitch was retired after his 1968 season to Normandy Farm in Kentucky. He ended his career with twenty-three wins in sixty-six starts with thirteen seconds, six thirds and $229,217 in earnings. He died in 1983 and is buried at Normandy Farm. He was elected to the Aiken Thoroughbred Racing Hall of Fame on January 23, 1977.

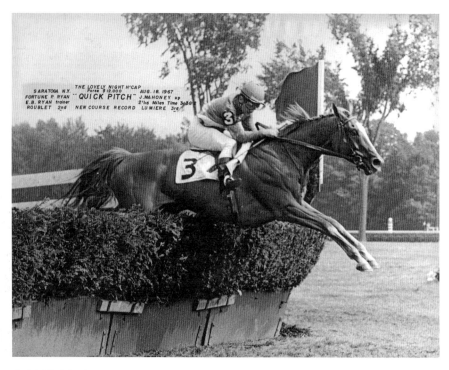

Quick Pitch in the 1967 Lovely Night Handicap. *Aiken Thoroughbred Racing Hall of Fame Archives*.

RELAXING

Relaxing, a bay mare, was foaled on May 5, 1976, in Kentucky. She was sired by Buckpasser, who won the 1966 Travers Stakes, Woodward Stakes, Brooklyn Handicap and the Jockey Club Gold Cup. Her dam was Marking Time, winner of the 1966 Acorn Stakes. She was bred and owned by Ogden Phipps (1908–2002), the son of Henry Carnegie Phipps and Gladys Livingston Mills. His grandfather Henry Phipps was a major philanthropist who had amassed a fortune as the second-largest shareholder in the Carnegie Steel Company. Sensational was trained by National Racing Hall of Fame trainer Angel Penna Sr. (1923–1992).

Relaxing's three-year career began in 1979, when she started in nine races, winning four (Maiden Special Weight and allowance) and earning $15,474. Her sophomore season, 1980, was a good one, with wins in the Gallant Fox Handicap (G2) and the Firenze Handicap (G2). She started twelve races, winning five, with one second, two thirds and $183,400 in earnings.

Relaxing's last racing season would be her most successful, winning two Grade 1 races. The Delaware Handicap (G1) was held on August 23 at Delaware Park. There were ten entries competing in the 1¼-mile race. Relaxing's rider was Angel Cordero Jr. She began the race in ninth place but started moving up in the backstretch and, by the ¾-mile mark, had moved into fifth. W.F. Walker's Lady of Promise led the race from the start until the 1-mile mark. In the stretch, Relaxing passed Lady of Promise for first and led by one length. Wistful, owned by Bright View Farm, passed Lady of Promise for second in the stretch but couldn't catch Relaxing. Relaxing won by 2¾ lengths over Wistful and by 3¾ lengths over Lady of Promise in a time of 2:01.

The Ruffian Handicap (G1) was held on September 27 at Belmont Park. This race was 1⅛ miles and had only four entries. Relaxing, again ridden by Angel Cordero Jr., was outrun early in the race and stayed in last place from the start until the ½-mile mark. But she began to quickly move up the field and, at the top of the stretch, had taken the lead from Love Sign, owned by Stephen C. Clark Jr. Love Sign wasn't ready to give up, and the two battled down the stretch with just a head separating them. Relaxing was able to hold on for the win by just ¾ of a length and in a time of 1:47 3/5.

She also won the John B. Campbell Handicap (G2) at Bowie Race Track and the Assault Handicap at Aqueduct. She finished her racing season at

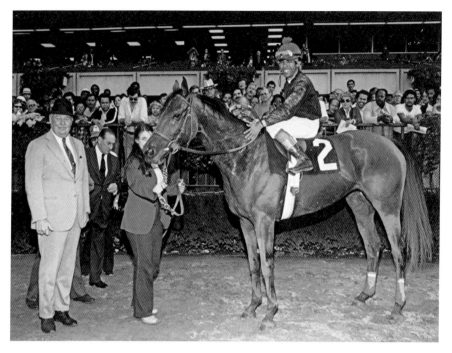

Relaxing after winning the 1981 Ruffian Handicap. *Aiken Thoroughbred Racing Hall of Fame Archives.*

the Jockey Club Gold Cup on October 10, finishing third, less than a length behind winner John Henry. The Phipps mare finished her 1981 season with four wins in seven starts, with two thirds and $390,321 in earnings. She won an Eclipse Award as the 1981 Champion Older Mare.

Relaxing was retired after her 1983 season to become a broodmare at Claiborne Farm in Kentucky. Her career record was twenty-eight starts with thirteen wins (six graded stakes), two seconds, five thirds and career earnings of $589,195. She was named the 1989 Kentucky Broodmare of the Year. Her most famous offspring was Easy Goer, which won the 1988 Champagne Stakes (G1) and the 1988 Breeders' Cup Juvenile (G1) and was given the 1988 Eclipse Award as the Champion Two-Year-Old Colt. Easy Goer also won the 1989 Belmont Stakes (G1) and the Wood Memorial Stakes (G1). Relaxing died on May 21, 1999, at age twenty-three from foaling complications and is buried at Claiborne Farm. She was elected to the Aiken Thoroughbred Racing Hall of Fame on March 14, 1982.

SENSATIONAL

Sensational, a dark bay or brown mare, was foaled on April 22, 1974, at Mill House Stable in Kentucky. Her sire was Hoist the Flag, the 1970 Champion Two-Year-Old Colt. Her dam was Meritus, who won the 1967 Spinaway Stakes and whose sire was Bold Ruler, winner of the 1957 Preakness Stakes. Sensational was bred and owned by Mill House Stable. Mill House is owned by Nicholas F. Brady, who was the U.S. secretary of the treasury under Presidents Ronald Reagan and George H.W. Bush. She was trained by National Racing Hall of Fame member Woody Stephens.

She won her first race, a Maiden Special Weight at Belmont Park, on June 28, 1976. She won her first stakes race on July 7 at Monmouth Park in the Colleen Stakes (Division 2). Sensational also won the Selima Stakes (G1) and the Astarita Stakes (G3).

One of her biggest wins of the year was in the Frizette Stakes (G1), held on October 4 at Belmont. The 1-mile race had seven entries, with Windfield Farm's Northern Sea rated the favorite to win. Mrs. Taylor Hardin's Mrs. Warren was

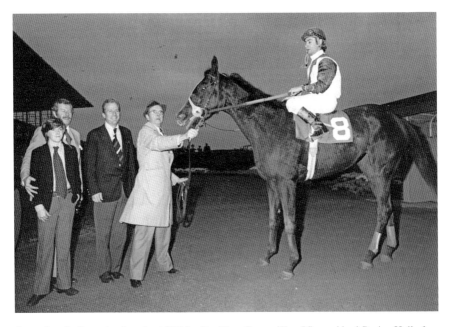

Sensational after winning the 1977 Ladies Handicap. *Aiken Thoroughbred Racing Hall of Fame Archives.*

the second favorite, and Sensational was the third favorite. Sensational, ridden by Jorge Velasquez, moved from fourth in the first ¼-mile mark of the race to second by the ½-mile mark. The Mill House Stable mare held that position until the stretch, where she overtook Northern Sea in the final ⅛ mile and won by 1½ lengths in a time of 1:36 1/5. Mrs. Warren finished third, 4½ lengths behind Sensational. Sensational finished her 1976 season with five wins in eleven starts, with one second, two thirds and $218,710 in earnings. She won an Eclipse Award as the 1976 Champion Two-Year-Old Filly.

Sensational would race two more years, winning the 1977 Ladies Handicap (G1), the 1977 Post-Deb Stakes (G3) and the 1978 Hawthorne Handicap. She was retired after her 1978 season, with nine wins in forty-four starts, nine seconds, nine thirds and $496,395 in earnings. She never produced a live foal as a broodmare and was pensioned in the mid-1980s. Sensational died in 2000 from infirmities of old age at twenty-six at Claiborne Farm. She was elected to the Aiken Thoroughbred Racing Hall of Fame on March 20, 1977.

SHUVEE

This chestnut mare was foaled on January 22, 1966, at Mill House Stable in Virginia. Her sire was Nashua, winner of the 1955 Preakness and Belmont Stakes. Her dam was Levee, who won the 1956 Beldame Stakes and was the 1970 Kentucky Broodmare of the Year. Shuvee was bred by Whitney A. Stone (1908–1979) and owned by his wife, Anne Minor Stone (1913–1987). She was trained by Willard C. "Mike" Freeman (1913–1998).

Shuvee began her racing career in 1968, winning three races in thirteen starts, with four seconds, three thirds and $209,396 in earnings. She won her first race on August 20, a six-furlong Maiden Special Weight race at Saratoga. She also won two important stakes races, the Frizette Stakes and the Selima Stakes. Shuvee had an excellent season in 1969. She won the Cotillion Handicap, the Ladies Handicap and the Alabama Stakes. She also won the Acorn Stakes, the Mother Goose Stakes and the Coaching Club American Oaks. These three races made up the Filly Triple Crown. She came in second to Gallant Bloom as the 1969 Champion Three-Year-Old Filly. Shuvee finished the season with six wins in twelve starts, with two seconds, two thirds and $312,894 in earnings.

Shuvee's 1970 racing season would see her win the first of her two Jockey Club Gold Cups. She would also win the Top Flight Handicap, the Beldame Stakes and the Diana Handicap. The Jockey Gold Cup was held at Aqueduct on October 31. At two miles long, it was the longest flat race in the New York season. Ron Turcotte, who would later gain racing immortality by riding the great Secretariat to a 1973 Triple Crown, rode Shuvee in the Gold Cup. She was running against "the boys": Loud, owned by William Haggin Perry; Hydrologist, owned by Meadow Stables; Twogundan, owned by Ada L. Rice; and Scipion, owned by A.S. Mascarenhas. Shuvee took the lead from the start and set the pace for the entire race. Turcotte had instructions from Mike Freeman to let her run her own race. Hydrologist stayed from within a head to ½ length in second, but she would not be able to match Shuvee's pace and, in the stretch, fell back to third. Loud, in third through the top of the stretch, made a run at the filly, but Shuvee took off and finished in front of Loud by 2 lengths, winning the race in a time of 3:21 3/5. It was the first time a female horse won the Jockey Gold Cup. The win capped off an amazing season in which Shuvee won four races in ten starts, with one second and $166,303 in earnings. She was named the 1970 Champion Older Mare.

Shuvee's last year as a racehorse would come in her 1971 season. She was entered in nine races, winning three of them: the Top Flight Handicap, the Diana Handicap (for the second time) and the Jockey Club Gold Cup (for the second time). The 1971 Jockey Club Gold Cup would give the boys a second chance to dethrone the queen who beat them in 1970. The field included Loud, which finished second in the 1970 race, and Paraje, the 1969 winner of the Clásico Jockey Club de Venezuela. Jorge Velasquez rode Shuvee in this race. Polar Traffic, owned by Randolph Weinsier, set the early pace but slipped out of contention after the ½-mile mark. He conservatively raced Shuvee in fourth until the ½-mile mark, when she moved past Polar Traffic and took over first place. Loud was behind Shuvee and tried to make up ground coming into the final turn, but he didn't have enough speed to catch her. Loud fell back to third. Paraje moved to the outside of the field coming into the final turn and passed Loud to take over second and make a run for Shuvee. Velasquez clucked (making a low sound with the tongue) at the head of the stretch, and Shuvee took off and won her second Jockey

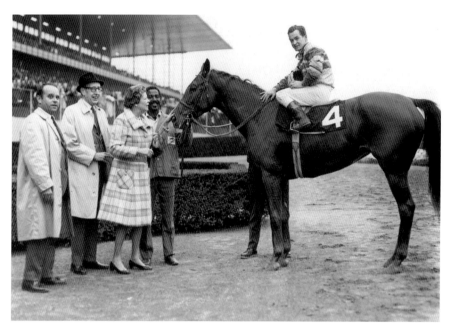

Shuvee after winning the 1970 Jockey Gold Cup. *Aiken Thoroughbred Racing Hall of Fame Archives.*

Club Gold Cup by seven lengths in a time of 3:20 2/5, besting her time in 1970. Paraje finished second, and Loud finished in third.

The race would be the last of the year and of Shuvee's career. She finished the 1971 season with three wins in nine starts with three seconds, one third and $166,445 in earnings. She won an Eclipse Award as the 1971 Champion Older Mare. Shuvee left racing with sixteen wins in forty-four starts, with ten seconds, six thirds and $890,445 in earnings. Her broodmare career resulted in eleven foals, with three of them stakes winners. Tom Swift, whose sire was Tom Rolfe, won the 1978 Seneca Handicap. Shukey, whose sire was Key to the Mint, won the 1978 Beaugay Handicap. Benefice, whose sire was Damascus, won the 1980 Ashford Castle Stakes in Ireland.

Shuvee was elected to the National Racing Hall of Fame in 1975. She died on April 1, 1986, due to complications from foaling. She was elected to the Aiken Thoroughbred Racing Hall of Fame on January 23, 1977.

SMART ANGLE

Smart Angle, a bay mare, was foaled on June 2, 1977, in Maryland. Her sire was Quadrangle, winner of the 1964 Belmont Stakes. Her dam was Smartaire, the 1979 Broodmare of the Year. She was bred and owned by Mr. and Mrs. James P. Ryan of Ryehill Farm and trained by National Racing Hall of Fame member Woody Stephens. Her freshman year of racing turned out to be her best; she never finished out of the money. Smart Angle was entered in nine races, winning six of them (all stakes wins), with two seconds and one third. She was known for winning at any distance and for her determination. Smart Angle won more races and earned more money than any other two-year-old filly in 1979.

She broke her maiden in her very first race, at Belmont Park on July 12. She won the 5½-furlong contest in a time of 1:05.20. She was ridden by Eddie Maple. Maple and his brother Sam would be her only riders her entire career. She won her first stakes race, the Lucky Penny Stakes at the now defunct Bowie Race Track, on July 29 with Sam Maple in the irons. In this 5½-furlong race, she came off the pace to win by a neck over Hail to Ambition in a time of 1:05.

The Spinaway Stakes at Saratoga was the first time that Smart Angle was listed as the favorite to win. This was a 6-furlong Grade 1 contest held on August 26. Smart Angle ran behind the early leader, A Little Affection, for most of the race, but she overtook her in the last quarter and opened up a 4-length lead. A Little Affection faded, and Smart Angle won by 1½ lengths over second-place finisher Jet Rating in a time of 1:10 3/5. Smart Angle next ran in the Grade 3 Adirondack Stakes at Belmont Park on September 10. In this 6½-furlong race, she placed third behind winner Royal Suite. This was her fifth race in nine weeks, and some people blamed the hectic schedule for Smart Angle's lackluster performance. Smart Angle and Royal Suite would meet up again in the Matron Stakes on September 24 at Belmont Park.

Sam Maple was up on Smart Angle for this 7-furlong race. She would be competing against four other horses: Royal Suite, owned by Reginald N. Webster; Nuit D'Amour, owned by Anthony C. Dauito; Tell a Secret, owned by Albert F. Polk; and Lady Hardwick, owned by Kentucky Blue Stables. The track was labeled as fast, and Royal Suite was the favorite to win. Smart Angle led from start to finish, but Royal Suite did not make it easy on her. Royal Suite eased back behind Smart Angle after the start and made her

move on the outside when approaching the stretch. The horses battled down the stretch, with Smart Angle hanging on for the win in a time of 1:23 4/5.

Royal Suite was the favorite to win the Frizette Stakes at Belmont Park on October 7. There was a large field of thirteen horses in this one-mile race. Smart Angle was in fourth place going into the quarter pole, 1½ lengths behind the leader, Sissy's Time. Nuit D'Amour was in the lead by the time the race was at the ½-mile point. Smart Angle was in third place, 2 lengths behind. Smart Angle and Royal Suite began moving up; by the time the race reached the ¾-mile pole, Smart Angle was in first, Nuit D'Amour was in second and Royal Suite was in third. Smart Angle took over the lead in the stretch and battled with Royal Suite before winning by 1¾ lengths over Royal Suite in a time of 1:38 1/5. Jeff Fell, Royal Suite's jockey, claimed interference from Smart Angle at the quarter pole, but his claim was disallowed. Royal Suite pulled up lame

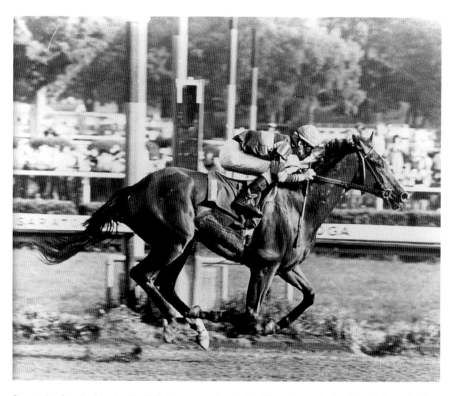

Smart Angle winning the 1979 Spinaway Stakes. *Aiken Thoroughbred Racing Hall of Fame Archives.*

after this race and, due to a torn suspensory ligament in her left front ankle, was retired from competition.

Smart Angle's final race of the season was the Demoiselle Stakes at Aqueduct on November 17. She was the favorite. Her main competition in this 1⅛-mile race was Genuine Risk, a filly who was undefeated in three starts. Smart Angle was raced conservatively but was kept close to the leaders. By the time the race entered the stretch, she was even with Genuine Risk. The two fillies raced neck to neck until the end. Genuine Risk won by a nose in a time of 1:51 1/5. Many considered this to be one of the best races in the 1979 two-year-old division. Smart Angle won an Eclipse Award as the 1979 Champion Two-Year-Old Filly. She would race for only two more seasons and ended up with a career record of seventeen starts, seven wins (seven graded stakes), four seconds, one third and $414,217 in earnings. Smart Angle died in 2001.

She was elected to the Aiken Thoroughbred Racing Hall of Fame on March 16, 1980.

SNOW KNIGHT

Snow Knight, a chestnut horse, was foaled in England on February 28, 1971. His sire was Firestreak and his dam was Snow Blossom, both from England. He was bred by J.A. Claude Lilley, owner of Quarry Stud in England. Snow Knight was owned in England by Sharon Phillips and trained there by Peter Nelson. Snow Knight was known as an unruly horse. In the paddock before the 1974 Epsom Derby, he threw jockey Brian Taylor and was fighting his handlers at the starting gate. Despite all the drama before the race, Snow Knight won the prestigious race by two lengths.

In the fall of 1974, Snow Knight was sold for a reported $1 million to Edward Plunkett Taylor, who owned Windfields Farm in Ontario, Canada. Snow Knight didn't perform well for his new trainer, Jim Bentley, so for the 1975 racing season, Snow Knight was sent to race in the United States. MacKenzie Miller spent months working with the high-strung colt. Snow Knight interacted well with his new trainer and won six races in nine starts. He would win the Manhattan Handicap (G2, Division 2), the Seneca Handicap (G3) (T) and the Brighton Beach Handicap (T) USA

(Division 2). His biggest win in the United States came in the Man o' War Stakes (G1).

The Man o' War Stakes was held on October 11 at Belmont Park. There were eight entries for the 1½-mile race. When the gates opened, Bobby Murcer, owned by Bourbon Hills Farm, took the lead and held it through the 1¼-mile mark. One on the Aisle, owned by Rokeby Stables, stayed within striking distance of Bobby Murcer throughout, making his move after the 1¼-mile mark to take the lead. Snow Knight, ridden by Jorge Velasquez, ran in fifth and fourth for most of the race and entered the stretch in third, with One on the Aisle in first place and Bobby Murcer in second. One on the Aisle crossed the wire in a time of 2:29 1/5, 1¾ lengths ahead of second-place Snow Knight. Drollery, owned by Greentree Stable, which passed Bobby Murcer to take third. However, that was not the end of the race. The riders of Snow Knight and Drollery both lodged a foul claim, stating that One on the Aisle had impeded them both in the stretch. Racing officials reviewed the race film and saw that One on the Aisle had repeatedly bumped Snow Knight in the stretch. The officials placed Snow

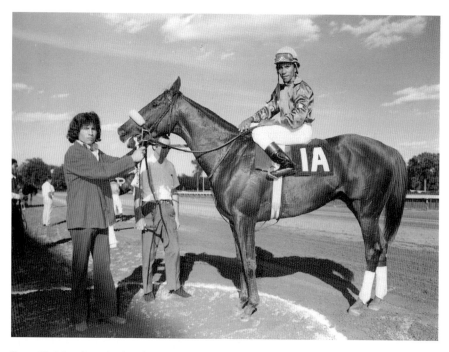

Snow Knight after winning the 1975 Seneca Handicap. *Aiken Thoroughbred Racing Hall of Fame Archives.*

Knight in first and dropped One on the Aisle to second. The claim from Drollery's rider, Mike Venezia, was denied.

Snow Knight finished his 1975 season with a victory in the Canadian International Championship Stakes (G1) at Woodbine. His statistics for the year were six wins (five graded stakes) in nine starts, with one second and $286,435 in earnings. Snow Knight won an Eclipse Award as the 1975 Champion Male Turf Horse.

Snow Knight was in training for the 1976 season when he sustained an injury to his suspensory ligament. He was retired with a career record of nine wins in twenty-two starts with five seconds, two thirds and $520,787 in earnings. He was sent to stud duty at Windfields Farm and then to Australia in 1986. He didn't have much success as a sire, but he did sire Awaasif, which won the 1982 Yorkshire Oaks in England. Snow Knight died on September 15, 1992, in Australia. He was elected to the Aiken Thoroughbred Racing Hall of Fame on January 23, 1977.

STAGE DOOR JOHNNY

Stage Door Johnny, a chestnut horse, was foaled in Kentucky on January 1, 1965. His sire was Prince John, who won the 1955 Garden State Stakes and was the leading Broodmare Sire in 1979, 1980, 1982 and 1986. Stage Door Johnny's grandsire was Princequillo (Ireland), winner of the 1943 Saratoga and Jockey Club Gold Cup Handicaps. His dam was Peroxide Blonde, which only produced four foals. Her sire, Ballymoss (Great Britain), in 1957 won the St. Leger Stakes and the Irish Derby and in 1958 won the Coronation Cup, Eclipse Stakes and King George VI & Queen Elizabeth Stakes. Stage Door Johnny was bred by Greentree Stud and owned by Greentree Stable. He was trained by John Gaver Sr.

The Greentree colt, as a weanling, was initially shipped to Greentree's Florida annex near Ocala. He was shipped back to Keeneland to be broken. While breezing on the track in September 1966, he bucked his shins. After recuperating, he was sent to the Aiken Training Track in December 1966 and the first part of 1967 for more training. Stage Door Johnny's career began in the fall of 1967, when he was entered in two maiden races. The colt did well, coming from off the pace to finish second in both races. Afterward,

he was sent back to Aiken for winter training. A magical 1968 racing season was just ahead.

Gaver entered Stage Door Johnny in the Peter Pan Purse on May 23. It was a nine-furlong race. Entries included the favorite T.V. Commercial, which had finished fourth in the Kentucky Derby. Stage Door Johnny, ridden by Heliodoro Gustines, started slow and was in fifth place at the 1/4-mile mark. He was in first place by a length at the 3/4-mile mark and at the top of the stretch. He quickly expanded his lead in the stretch to win by four lengths in a time of 1:48 2/5. Gaver announced after the win that Stage Door Johnny's first stakes race would come in the Belmont Stakes (G1) on June 1.

The Belmont Stakes, one of the most prestigious races in the world, was celebrating its 100th running. There was a field of nine competitors for the 1 1/2-mile race, and all bets were on Calumet Farm's Forward Pass as the favorite. A lot was riding on the results, as Forward Pass had already won the Kentucky Derby and the Preakness Stakes and was headed toward winning the elusive Triple Crown. Heliodoro Gustines got the call to ride Stage Door Johnny, and he kept a steady hand on his horse during the first 1/2-mile, then began moving him up in the backstretch and positioning him into third place at the 1-mile mark. He was about 1 3/4 lengths behind the leader, Forward Pass, and a head behind second-place Call Me Prince, owned by Adele Rand. The Greentree colt moved into second when he passed Call Me Prince at the 1 1/4-mile mark and set his eye on Forward Pass, now just a length ahead. He took the lead away from Forward Pass at the stretch and pulled away to win by 1 1/4 lengths over the favorite and spoiling his Triple Crown bid. Call Me Prince finished third, 13 1/4 lengths behind the winner. Stage Door Johnny won in a time of 2:27 1/5, the second-fastest Belmont finish at that time. He now shares the tenth-fastest time in the Belmont Stakes with Swale, which won in 1984, and Go and Go, the 1990 winner.

After his Belmont Stakes win, Stage Door Johnny went on to win the Saranac Handicap and the Dwyer Handicap. He finished the year with five wins in six starts, with one third and $221,765 in earnings. Stage Door Johnny was named the 1968 Champion Three-Year-Old Colt.

Stage Door Johnny was training at Saratoga, preparing for the annual twenty-four-day meet that would begin on July 29, when he was injured. The injury was diagnosed as a bowed tendon and resulted in him being retired from racing. He had a career record of five wins in eight starts, with two seconds, one third and $223,965 in earnings.

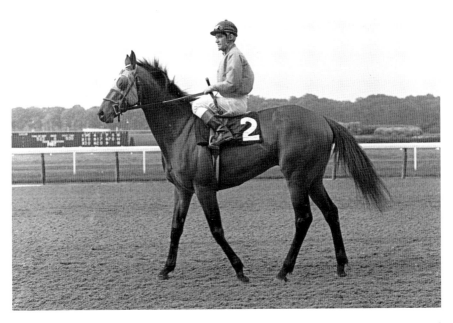

Stage Door Johnny on the way to the gate in the 1968 Saranac Handicap. *Aiken Thoroughbred Racing Hall of Fame Archives.*

He went to stand at stud at Greentree Stud in Lexington, Kentucky, and was a successful sire, with 130 offspring. He sired a number of notable horses, including the following: Open Call, winner of the 1981 Rothmans International Stakes; Class Play, winner of the 1984 Coaching Club American Oaks; Johnny D., winner of the 1977 Eclipse Award for Outstanding Male Turf Horse; and Late Bloomer, winner of the 1978 Eclipse Award for Outstanding Older Female Horse. Stage Door Johnny was the sire of Never Knock, which was the dam of Go for Gin, winner of the 1994 Kentucky Derby and the sire of Stage Luck. Stage Luck was the dam of Open Mind, winner of the 1988 Breeders' Cup Juvenile Fillies, winner of the 1988 Eclipse Award Champion Two-Year-Old Filly and winner of the 1989 Eclipse Award Champion Three-Year-Old Filly. Stage Door Johnny died in November 1996 at the age of thirty-one and is buried at Greentree Stud, now part of the Gainesway Farm property. He was elected to the Aiken Thoroughbred Racing Hall of Fame on January 23, 1977.

STORM SONG

Storm Song, a bay mare, was foaled on February 28, 1994, in Kentucky. Her sire was Summer Squall, who won the 1990 Preakness Stakes and finished second in the 1990 Kentucky Derby. Her dam was Hum Along, whose sire was Fappiano, winner of the 1991 Metropolitan and Suburban Handicaps. She was bred by William S. Farish and Ogden M. Phipps and was owned by Dogwood Stable of Aiken, South Carolina. Nick Zito, member of the National Racing Hall of Fame, was her trainer.

Her 1996 year of racing turned out to be her best. She won four races, including two Grade 1 races. She won her very first race, a Maiden Special Weight at Keeneland, on April 19, 1996. She also won the Adirondack Stakes (G2) at Saratoga on August 12.

The Frizette Stakes (G1) was held on October 6 at Belmont. The race was $1\frac{1}{16}$ miles with seven entries, including Sharp Cat, who had beaten Storm Song in the Matron Stakes (G1) on September 15. Craig Perret got the call to ride Storm Song. Desert Digger, ridden by Jose Santos, took the lead at the start of the race but only held it to the $\frac{1}{4}$-mile mark, when Sharp Cat, ridden by Jerry Bailey, passed him. Sharp Cat maintained the lead until the $\frac{3}{4}$-mile mark, when Storm Song, who was trailing by a head, passed Sharp Cat and increased her lead down the stretch to $1\frac{1}{2}$ lengths. Storm Song won by 4 lengths over Sharp Cat and 10 lengths over Aldiza in a time of 1:42.47.

The Breeders' Cup Juvenile Fillies (G1) took place on October 26 at Woodbine. Storm Song, with Craig Perret as jockey, faced Sharp Cat again in the $1\frac{1}{16}$-mile race. Love that Jazz, ridden by Mike Smith, took the early lead and held it until after the $\frac{3}{4}$-mile mark. Storm Song, who was in fifth place at the $\frac{3}{4}$-mile mark, exploded in the stretch and passed Love that Jazz to take the lead by a length. She increased her lead to $4\frac{1}{2}$ lengths to win in a time of 1:43.60. Love that Jazz came in second, and Critical Factor came from the back of the field to take third place. Storm Song finished the 1996 season with four wins in seven starts, with one second and $898,205 in earnings. Her outstanding performances in the Frizette Stakes and the Breeders' Cup Juvenile Fillies solidified her selection as the winner of the 1988 Eclipse Award Champion Two-Year-Old Filly.

Her 1997 season was not as successful as her 1996 one had been. She finished third in the Ashland Stakes (G1) and the Kentucky Oaks (G1). Her last race came in the Acorn Stakes (G1), where she finished seventh.

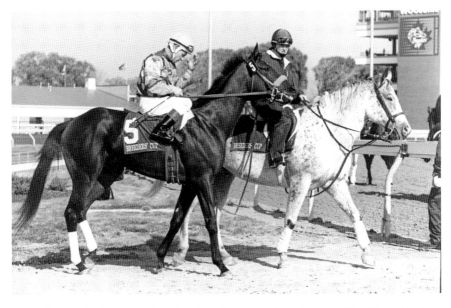

Storm Song at the 1996 Breeders' Cup Juvenile Fillies Championship. *Aiken Thoroughbred Racing Hall of Fame Archives.*

Her year ended with two thirds in five starts and $121,845 in earnings. Storm Song was retired on July 29, 1997, and was offered in Keeneland's November Breeding Stock Sale. She ended her career with four wins in twelve starts, with one second, two thirds and $1,020,050 in earnings. She was purchased on November 12, 1997, at Keeneland's Breeding Stock Sale for $1.4 million by Jamie S. Carrion. She produced the mare Another Storm, which was the dam of Order of St. George, winner of the 2016 Ascot Gold Cup. Storm Song was sold again at the 2009 Keeneland's November Breeding Stock Sale to Aaron Sones for $100,000. She produced Trojan Nation, a stallion that finished second in the 2016 Wood Memorial. Storm Song was elected to the Aiken Thoroughbred Racing Hall of Fame on March 16, 1997.

SWALE

This dark bay or brown horse was foaled at Claiborne Farm in Kentucky on April 21, 1981. His sire was Seattle Slew, who was the tenth U.S. Triple

Crown Champion (1977), U.S. Champion Two-Year-Old Colt (1976), U.S. Champion Three-Year-Old Colt (1977) and American Horse of the Year (1977). Swale's dam was Tuerta, winner of the 1973 Long Island Handicap (G3). Swale was bred and owned by Claiborne Farm and trained by National Racing Hall of Fame member Woody Stephens.

Swale began his racing career in 1983, which would be a very successful season. He won his first race in a Maiden Special Weight contest on July 21 at Belmont Park. He also won the Young America Stakes (G1), the Breeders' Futurity (G2), the Futurity Stakes (G1) and the Saratoga Special Stakes (G2). He finished his first year of racing with five wins in seven starts with one second, one third and $491,950 in earnings.

Swale would shine in his 1984 season, with wins in the Hutcheson Handicap (G3), Florida Derby (G1), Kentucky Derby (G1) and Belmont Stakes (G1). The 1¼-mile Kentucky Derby, held on May 5, had twenty entries. Althea, which won an Eclipse Award as the 1983 Champion Two-Year-Old Filly and won the 1984 Fantasy Stakes (G1), was the first filly to be favored to win the Derby since 1935. When the gates opened, Althea went to the head of the field and maintained her lead through the ¾-mile mark. Swale, ridden by Laffit A. Pincay Jr., started off in third but was within a head of Althea at the ¾-mile mark. Swale passed her on the backstretch and, on reaching the 1-mile mark, had increased his lead to 2 lengths. At this point in the race, Althea had fallen back to fifth and continued to fall back until she finished nineteenth in the field of twenty. Coax Me Chad, which was in seventh place at the 1-mile mark, closed quickly on the field and moved up to second place in the stretch, 5 lengths behind frontrunner Swale. At the Threshold, which was in sixth place at the ¾-mile mark, had moved up to third in the stretch and was ½ length behind Coax Me Chad. Coming down the stretch, Coax Me Chad cut into Swale's lead but didn't have enough left to continue to challenge him for the win. Swale won by 3¼ lengths in a time of 2:02 2/5. Coax Me Chad finished second, 2 lengths in front of At the Threshold, which finished third. The $537,400 Swale won in the Derby brought his career earnings to $1,273,641, making him Thoroughbred racing's forty-eighth millionaire.

Swale was the favorite to win the Preakness Stakes, held on May 19 at Pimlico. The race was a disappointment for Swale's team, as he finished seventh in a field of ten. Swale's rider, Laffit A. Pincay Jr., commented

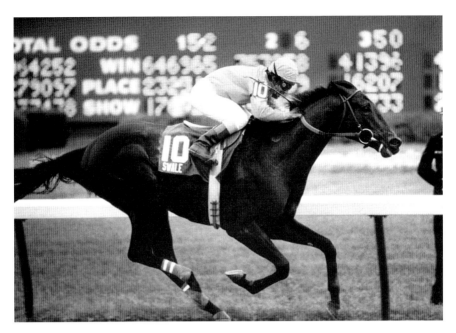

Swale winning the 1984 Kentucky Derby. *Aiken Thoroughbred Racing Hall of Fame Archives.*

that he just didn't seem to be the same horse he had ridden in the Derby. Whatever was bothering Swale in the Preakness was apparently cured by the time the Belmont Stakes came around.

The Belmont Stakes was held on June 9, and there were eleven horses in the field, including Gate Dancer, which won the Preakness Stakes. This would indeed be a different Swale than the one that ran in the Preakness. Swale led the 1½-mile race from start to finish. The closest any of the other horses got to him was one length and that was in the first ½ mile of the race. Pine Circle, ridden by Pat Day, came from ninth with 1 mile to go to finish second, four lengths behind the winner. Swale won in a time of 2:27 1/3.

Tragically, Swale died on June 17, during a morning bath, a week after the Belmont Stakes. The New Bolton Center of the University of Pennsylvania's School of Veterinary Science tested his heart and found a very small area of fibrosis below the aortic valve and lesions of this type can produce an arrhythmia in the heart, which can be fatal. His second year of racing ended with four wins in seven starts, with one second, one third and $1,091,710 in earnings. His career ended with nine wins in

fourteen starts, with two seconds, two thirds and $1,583,660 in earnings. He was buried at Claiborne Farm. Swale won an Eclipse Award as the 1984 Champion Three-Year-Old Horse. He was elected to the Aiken Thoroughbred Racing Hall of Fame on March 16, 1985.

TEA-MAKER

Tea-Maker, a bay horse, was foaled in 1943 in Kentucky. His sire was Only One, winner of the 1935 American Legion and Delaware Handicaps. His dam was Tea Leaves. Tea-Maker was bred by Mrs. F. Ambrose Clark and owned by F. Ambrose Clark. He was trained by J. Dallet "Dolly" Byers (1898–1966), who was inducted into the National Racing Hall of Fame in 1961 as a jockey.

Tea-Maker began his racing career in 1948 at five years of age and won his first race, an allowance, at Belmont Park on May 21. His race record from 1948 to 1951 was eighty-one starts with twenty wins, fifteen seconds, eleven thirds and $119,925 in earnings. He won the 1950 Vosburgh Handicap, the 1951 American Legion Handicap and the 1951 Autumn Day Handicap.

Tea-Maker's best season was in 1952, when he won four major races, including the Fleetwing Handicap and the Wilmington Handicap. He was one of seven entries in the Jamaica Handicap, held on April 16 at Jamaica Race Track in New York. The race was six furlongs in length, and Hedley Woodhouse got the call to ride Tea-Maker. The nine-year-old horse, described as "frisky as a 2-year-old," took the lead from the start of the race and never relinquished it. He led by 3 lengths at the stretch over H.P. Headley's Jumbo and $3\frac{1}{2}$ lengths over Squared Away, in second and third places, respectively. Ted Atkinson, riding Greentree's Northern Star, was able to drive his horse down the stretch to pass Jumbo and Squared Away to take over second, but he was unable to catch Tea-Maker, which won by $2\frac{1}{2}$ lengths in a time of 1:11 1/5. Wollford Farm's Delegate was able to get up to finish third.

The American Legion Handicap was held on August 15 at Saratoga. This was a seven-furlong race with six entries. Tea-Maker faced Greentree's Northern Star again, as well as the race favorite, George D. Widener's

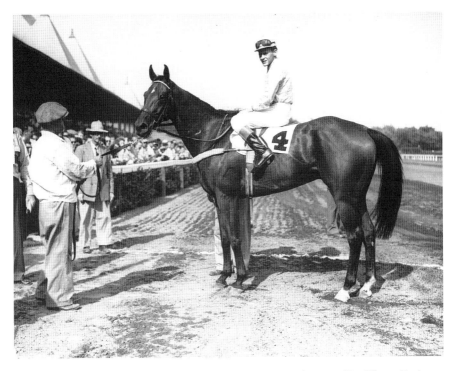

Tea-Maker with jockey William J. Passmore, date and race unknown. *Aiken Thoroughbred Racing Hall of Fame Archives*.

Battlefield. Tea-Maker, ridden again by Hedley Woodhouse, started the race in second place, but it didn't take long for the horse to take over first; by the 3/8-mile mark, he was leading by 1/2 length over Northern Star. Entering the stretch, Tea-Maker was still leading by 1/2 length over Alfred G. Vanderbilt's First Glance, who had taken over second from Northern Star. Woodhouse rode Tea-Maker to the win by 3/4 length in a time of 1:25 3/5, with First Glance finishing second and Northern Star third. This was the second consecutive year that Tea-Marker won this race. He finished the 1952 racing season with twenty-one starts, six wins, five seconds, four thirds and $72,180 in earnings. He was named the 1952 American Champion Sprinter.

He would run again in 1953, starting in 13 races and winning 3, with three seconds, one third and $19,425 in earnings. He was retired at the end of the year. Tea-Maker's career ended with an incredible 115 starts with twenty-nine wins, twenty-three seconds, sixteen thirds and $211,530 in earnings. He spent his retirement years at F. Ambrose Clark's estates

in Aiken, South Carolina; Westbury, New York; and Cooperstown, New York, staying a portion of the year at each estate. Tea-Maker made an appearance at the March 18, 1961 Aiken Trials, his first public appearance in a number of years. Tea-Maker was elected to the Aiken Thoroughbred Racing Hall of Fame on January 23, 1977.

TOM FOOL

Tom Fool, a bay horse, was foaled in Kentucky in 1949. His sire was Menow, winner of the 1937 Champagne Stakes and the 1937 Belmont Futurity Stakes and voted the 1937 American Champion Two-Year-Old Male Horse. His dam was Gaga, the 1953 Broodmare of the Year. Tom Fool, bred by Duval A. Headley and owned by Greentree Stable, was trained by John Gaver Sr.

Tom Fool's racing career began in 1951, when he won the first race in which he was entered, a Maiden Special Weight at Saratoga on August 13. Ted Atkinson, National Racing Hall of Fame member, was his rider, not only for this race, but for Tom Fool's entire career. He won four major races in 1951, including the Sanford Stakes and the Grand Union Hotel Stakes. He ran in the Futurity Stakes on October 6 at Belmont. This race was considered the top race for two-year-olds in the country. There were ten entries in the 6½-furlong contest. Marlboro Stud Farm's Jet Master, ridden by Eddie Arcaro, took the early lead and held it until the ½-mile mark. Tom Fool was in fourth place until the ½-mile mark, when, under strong urging from Atkinson, he took the lead in the last 250 yards of the race, winning by 1⅗ lengths in a time of 1:17 1/5. Starmount Stables' Primate, ridden by Willie Shoemaker, moved up from seventh place at the beginning of the stretch to take second.

Tom Fool's last win of the year came in the East View Stakes on October 24 at Jamaica Race Track. There were six entries in the 1¹/₁₆-mile race, and Tom Fool was the favorite to win. He started the race in third and dropped back to fourth at the ¾-mile mark. Jack J. Amiel's Mr. Turf was the early leader, but he dropped to last place at the beginning of the stretch. Tom Fool, Lazy F Ranch's Put Out and Maine Chance Farm's Jet's Date were within ½ length of one another coming down the stretch. Tom Fool held

on to win by a neck over Put Out. Jet's Date fell back to fourth when King Ranch's Risque Rouge passed him for third. Tom Fool won by a neck in a time of 1:45 1/5. He would finish his freshman year with five wins in seven starts with two seconds and $155,960 in earnings. Tom Fool was named the 1951 Champion Two-Year-Old Colt.

Tom Fool would start in thirteen races in 1952. He won the Grey Lag Handicap, the Empire City Handicap, the Jerome Handicap, the Sysonby Handicap and the Wilson Stakes. He won six races in thirteen starts, with five seconds, one third and $157,850 earnings, but it was not enough to get him top honors as the 1952 Champion Three-Year-Old. That honor went to Sarah F. Jeffords's One Count, winner of the Belmont Stakes Jockey Club Gold Cup and the Travers Stakes.

Tom Fool had an incredible season in 1953, winning every race in which he was entered, including an unnamed sprint race at Jamaica Race Track, the Carter Handicap, the Joe Palmer Handicap, the Sysonby Mile, the Pimlico Special, the Whitney Stakes and the Wilson Stakes. He also won the Handicap Triple Crown, which consisted of the Metropolitan, the Suburban and the Brooklyn Handicaps. He was the first horse since Whisk Broom II in 1913 to accomplish the feat.

The Metropolitan Handicap was held on May 23 at Belmont. Tom Fool was the favorite to win the 1-mile race, which had seven entries. He was in third at the start of the race and worked his way to second at the 1/4-mile mark. Jack J. Amiel's Mr. Turf, second in the first part of the race, moved into first at the 1/4-mile mark, leading Tom Fool by 1 1/2 lengths. Once the Greentree star reached the 3/4-mile mark, he had taken over the lead; Brookfield Farms' Intent had passed Mr. Turf to take over second. Entering the stretch, Tom Fool had a 1 1/2-length lead over Mrs. Ester du Pont Weir's Royal Vale, who had passed Intent to take over second. Tom Fool won in a time of 1:35 4/5, 1/2 length ahead of Royal Vale. Tom Fool's time was only four-fifths of a second off the race record.

The Suburban Handicap, held on May 30 at Belmont, was 1 1/4-mile race with seven entries. Royal Vale would have another chance to defeat the favorite, Tom Fool. At the 1/2-mile mark, Tom Fool and Royal Vale were first and second, respectively, separated by two lengths. Tom Fool increased his lead to three lengths through the 1-mile mark, but once entering the stretch, Royal Vale chipped the lead down to one length. The two horses battled down the stretch, with Tom Fool holding on to his lead

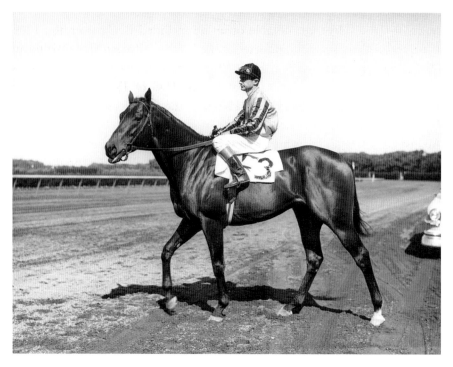

Tom Fool with jockey Ted Atkinson, date and race unknown. *Aiken Thoroughbred Racing Hall of Fame Archives.*

and winning by a nose in a time of 2:00 3/5. The rest of the field was more than seven lengths back.

The Brooklyn Handicap was held at Aqueduct on July 11. Tom Fool and four other horses competed in the 1¼-mile race. After being slightly bumped at the start of the race, Tom Fool quickly recovered and was in second before the ¼-mile mark. Golden Gloves, owned by Belair Stud, had the early lead, but by the time they reached the 1-mile mark, Tom Fool had passed him and was leading by 3½ lengths. In the stretch, Golden Gloves cut into Tom Fool's lead by ½ length but couldn't rally to get closer. Tom Fool won by 1½ lengths in a time of 2:04 2/5. His earnings that year were $256,355. Tom Fool was named the 1953 Champion Sprinter, the 1953 Champion Older Horse and the 1953 Horse of the Year. He was retired after the 1953 season and ended his career with twenty-one wins in thirty starts, with seven seconds, one third and $570,165 in earnings.

He began his stud career at Greentree, where he sired over 125 offspring. His offspring won over 650 races in America and England, with over thirty

stakes winners. His most notable offspring included Buckpasser, the 1966 U.S. Horse of the Year and inductee of the National Racing Hall of Fame in 1970, and Tim Tam, winner of the 1958 Kentucky Derby, 1958 Preakness Stakes and inductee of the National Racing Hall of Fame in 1960. Tom Fool was the fourth-leading sire in 1965 and the third-leading sire in 1966. He was inducted into the National Hall of Fame in 1960. Tom Fool died on August 20, 1976, and was buried at Greentree Stud (now Gainesway Farm) in Lexington, Kentucky. He was elected to the Aiken Thoroughbred Racing Hall of Fame on January 23, 1977.

BIBLIOGRAPHY

Aiken Standard (South Carolina)

American Race Horses 1942. New York: Sagamore Press, 1943.

American Race Horses 1943. New York: Sagamore Press, 1944.

American Race Horses 1944. New York: Sagamore Press, 1945.

American Race Horses 1946. New York: Sagamore Press, 1946.

American Race Horses 1948. New York: Sagamore Press, 1949.

American Race Horses 1949. New York: Sagamore Press, 1950.

American Race Horses 1950. New York: Sagamore Press, 1951.

American Race Horses 1951. New York: Sagamore Press, 1952.

American Race Horses 1952. New York: Sagamore Press, 1953.

American Race Horses 1953. New York: Sagamore Press, 1954.

American Race Horses 1960. New York: Sagamore Press, 1961.

American Race Horses 1961. New York: Sagamore Press, 1962.

American Race Horses 1962. New York: Sagamore Press, 1963.

Blood-Horse, Inc. *Horse Racing's Top 100 Moments.* Lexington, KY: Eclipse Press, 2006.

Blood-Horse magazine (1942–2014).

————. *Thoroughbred Champions: Top 100 Racehorses of the 20th Century.* Lexington, KY: The Blood-Horse, 1999.

Daily Racing *Form Champions: The Lives, Times, and Past Performances of America's Greatest Thoroughbreds.* Rev. ed. Daily Racing Form, 2005.

Daily Racing Form.

New York Times.

INDEX

ABOUT THE AUTHOR

Lisa J. Hall has worked for the City of Aiken Parks, Recreation & Tourism Department for over thirty years. She took over supervision of the Aiken Thoroughbred Racing Hall of Fame and Museum in 2010. She holds a BA in education from the University of South Carolina–Aiken. A lover of history and horses for her entire life, Lisa grew up in Aiken, South Carolina, a community known for its love of all things equestrian. She volunteers with the Aiken Trials and the Aiken Steeplechase Association. Lisa currently resides in Vaucluse, South Carolina.